POSTCARD HISTO

San Jose

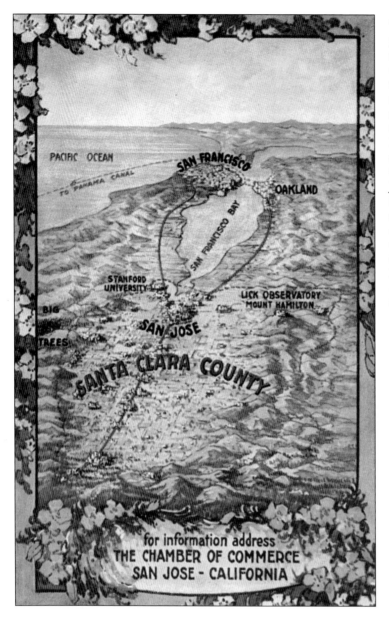

This floral-framed postcard, issued by the San Jose Chamber of Commerce, shows the town's strategic commercial location near San Francisco, Oakland, and San Francisco Bay. The chamber also wanted to point out San Jose's proximity to Stanford University and to major points of interest like Lick Observatory and the big trees of Big Basin State Park. (Courtesy of the California Room.)

ON THE FRONT COVER: A curious biplane circles the Electric Light Tower in this scene of downtown San Jose around 1910. The 237-foot Electric Light Tower dominates the intersection of Market and Santa Clara Streets. To the right of the tower is the five-story Rea Building. To the right of the Rea Building is the tower behind the fire department headquarters, which held the fire alarm bell. (Courtesy of the California Room.)

ON THE BACK COVER: A fountain flows in the gardens of the Winchester House owned by Sarah Winchester. In the background is part of the sprawling 160-room mansion built by Winchester during the 38 years she lived in San Jose. Renamed the Winchester Mystery House after her death, the mansion on Winchester Boulevard is now a popular tourist attraction. (Courtesy of the Sourisseau Academy.)

POSTCARD HISTORY SERIES

San Jose

Bob Johnson

ARCADIA
PUBLISHING

Published by Arcadia Publishing
Charleston SC, Chicago IL, Portsmouth NH, San Francisco CA

Printed in the United States of America

Library of Congress Control Number: 2009943766

For all general information contact Arcadia Publishing at:
Telephone 843-853-2070
Fax 843-853-0044
E-mail sales@arcadiapublishing.com
For customer service and orders:
Toll-Free 1-888-313-2665

Visit us on the Internet at www.arcadiapublishing.com

*This book is dedicated in gratitude to Jack Douglas,
librarian, archivist, historian, teacher, writer, preservationist,
and General Naglee impersonator.
Jack's years of devotion to local history and preservation
are an inspiration to all who care about the past and future of San Jose.*

CONTENTS

Acknowledgments 6

Introduction 7

1. The Heart of the City 9

2. Halls of Learning 23

3. Sights and Diversions 41

4. Civic Buildings 65

5. Alum Rock Park 77

6. The Garden City 91

7. Community 103

Bibliography 127

ACKNOWLEDGMENTS

All the images in this book were found in the postcard collections of two extraordinary local history collections: the San Jose Public Library California Room and the Sourisseau Academy for State and Local History. Special thanks must go to Charlene Duval, executive secretary of the Sourisseau Academy for State and Local History, and to Stacy Mueller, lead librarian of the California Room. Without their enthusiasm and generous access to their collections this book would never have been written. I also wish to thank the board of directors of the Sourisseau Academy for State and Local History and the library administration of the San Jose Public Library for their support. I must also express my debt to Jack Douglas for the donation of his postcard collection to the Sourisseau Academy for State and Local History. Many of his donated postcards were used in this book. Douglas's books, articles, and writings were also very helpful in the research done for this book. I want to give warm thanks to my wife, Lauren Miranda Gilbert, for her support, suggestions, comments, proofreading, and patience during the long period of writing and assembling this book. Finally, I must recognize the assistance of our two cats, Cali and Myles, who generously gave of their time to nap on my notes and to walk back and forth in front of the computer screen whenever I was trying to work.

INTRODUCTION

San Jose has a long history, reaching back more than 200 years. It is the oldest civilian settlement in California, founded by the Spanish in 1777 to provide food for the military settlements in San Francisco and Monterey. In the first half of the 19th century, San Jose was a small pueblo in the midst of ranchos raising cattle and horses. After California was admitted as a state in 1850, San Jose became the first state capital. San Jose remained the state capital until 1852, when the state legislature voted to move to Vallejo.

By 1900, San Jose was a thriving city of 21,000 surrounded by orchards and fields. It was the financial, retail, manufacturing, and service center of the valley's agricultural industry. It was at this time that the collecting and sending of postcards became popular here and around the world. In the following years, hundreds of postcards of San Jose and the surrounding areas were issued. These postcards provide a unique glimpse of the San Jose of the past.

It is admittedly a somewhat restricted glimpse, for not all aspects of San Jose life were thought to be suitable subjects for postcards. Postcards depicted places, scenery, and events of which citizens were most proud and wished to share with visitors. Postcards are not like photographs, which often capture a spontaneous moment. Instead these historic images highlighted the best views of San Jose; those images that residents and civic boosters hoped would represent San Jose most favorably to the rest of the country. Some postcards were published by the San Jose Chamber of Commerce, with the intent of promoting the city as a great place to visit, establish a business, or take up residence. Even with these limitations, postcards still provide a valuable look into San Jose's past, because the city has changed so much since they were first published in the early 20th century.

A resident from the early 20th century suddenly transported into present-day San Jose would be dazed and confused with hardly any recognizable landmarks to serve as an anchor. Like most cities, San Jose grew and changed during the first half of the 20th century. But after World War II, the rate of change accelerated to a degree almost unknown in modern urban development. By 2010, that small early-19th-century city of 21,000 had become the tenth largest city in the United States, with a population of more than 1 million. The orchards, fields, and vacant lots that had once surrounded the city were gone, replaced by freeways, houses, strip malls, shopping centers, and industrial parks. With the passing of the orchards, agriculture was no longer the local economic engine. During the postwar boom, San Jose became a center of high technology, the "Capital of Silicon Valley," as local politicians and businessmen were fond of describing it. Semiconductor manufacturing gave way to high technology research and development. Start-up companies strove for the next big thing in software development and Internet applications. Solar power and clean energy companies proliferated.

While these developments have brought people, jobs, and prosperity to San Jose, they have also brought profound changes to the face of the city. Buildings, streets, landscapes, and a way of life have been lost for good. For those who have lived through these changes, postcards can take us back. They are able to remind us of the San Jose that used to be. For more recent arrivals lured by the opportunities here, postcards can educate, teach, and show what San Jose was like before the massive changes took place. Finally, postcards help us appreciate those places and structures that have managed to survive though the years.

One

THE HEART OF THE CITY

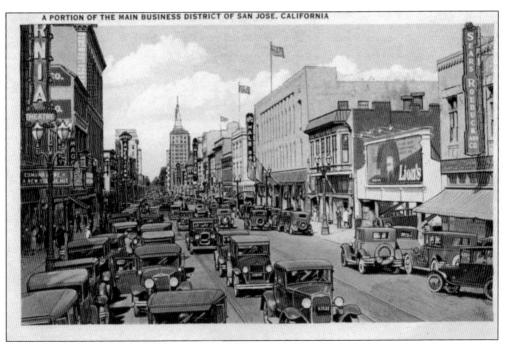

A PORTION OF THE MAIN BUSINESS DISTRICT OF SAN JOSE, CALIFORNIA

In the first half of the 20th century, downtown San Jose was the business and financial heart of the city. Many of these businesses were located on First Street. Here is a busy section of South First Street looking north from San Salvador Street. On the left is the California Theatre and in the background the Bank of Italy tower. (Courtesy of the Sourisseau Academy.)

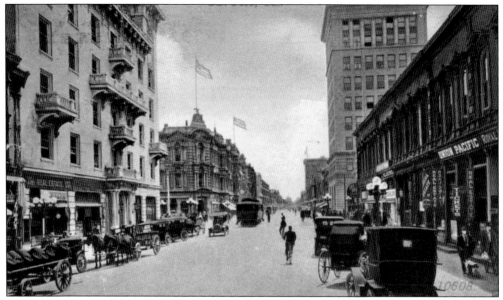

The meeting of First and Santa Clara Streets was the financial crossroads of the city. Three banks are visible in this 1910 view looking south on First Street toward the intersection with Santa Clara Street. On the far left is the Bank of San Jose. The building on the rear left with the flag is the San Jose Safe Deposit Bank. The tall building on the right is the First National Bank of San Jose. (Courtesy of the Sourisseau Academy.)

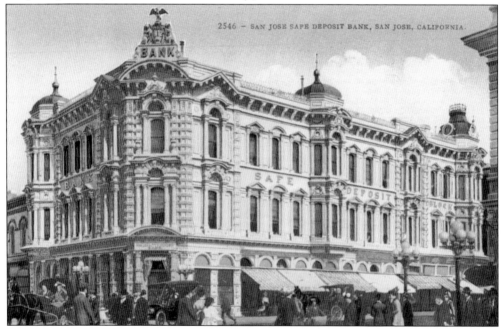

The solid appearance of the San Jose Safe Deposit Bank must have inspired confidence in its customers. The bank's advertising boasted of its fireproof and burglar-proof vault, measuring 31 feet long and 12 feet wide. Founded in 1885, the bank stood at the southeast corner of First and Santa Clara Streets. It was demolished in 1925 to make way for the new Bank of Italy building. (Courtesy of the California Room.)

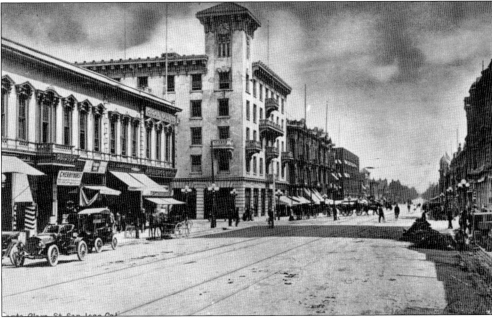

The Bank of San Jose was located on the northwest corner of the busy intersection of First and Santa Clara Streets. Founded in 1866, it was the oldest bank in the city. After its original building was damaged in the 1906 earthquake, the bank built this five-story structure of reinforced concrete. The four-sided clock in the tower served as the community timepiece, since it was high enough to be seen throughout downtown and its striking bell could be heard even farther. In 1927, the Bank of San Jose was absorbed by the Bank of Italy, located across the street. The former Bank of San Jose structure was demolished in 1947. The clock was salvaged and now keeps time for shoppers at the Glendale Galleria shopping center in Southern California. (Above, courtesy of the Sourisseau Academy; at right, courtesy of the California Room.)

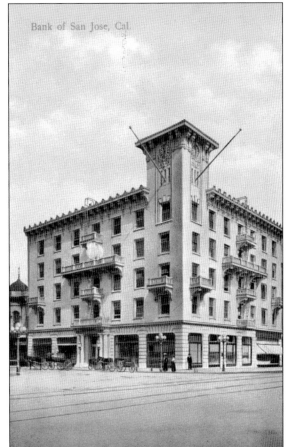

Bank of San Jose, Cal.

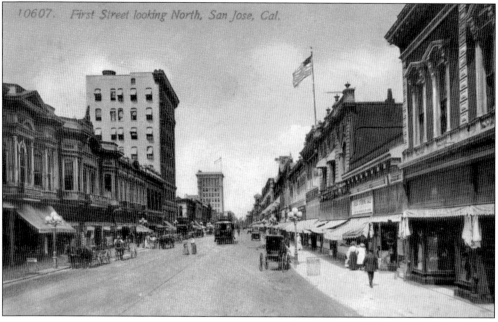

10607. First Street looking North, San Jose, Cal.

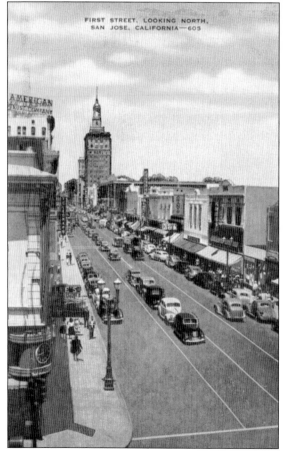

FIRST STREET, LOOKING NORTH,
SAN JOSE, CALIFORNIA—605

The changes in downtown San Jose can be clearly seen in these two postcards, with scenes taken about 30 years apart. The view in both is from San Antonio Street (now Paseo de San Antonio) looking north on First Street toward Santa Clara Street. Note the horse-drawn vehicles and quiet streets in the older postcard (above). Contrast that with the later postcard (at left) showing the busy street crowded with automobiles and lined with modern stores. In both postcards the Garden City Bank Building can be seen on the left, although in the later scene it is topped with the sign of its new name, the American Trust Company. The most dramatic change is the appearance in the later postcard of the Bank of Italy tower. (Both, courtesy of the Sourisseau Academy.)

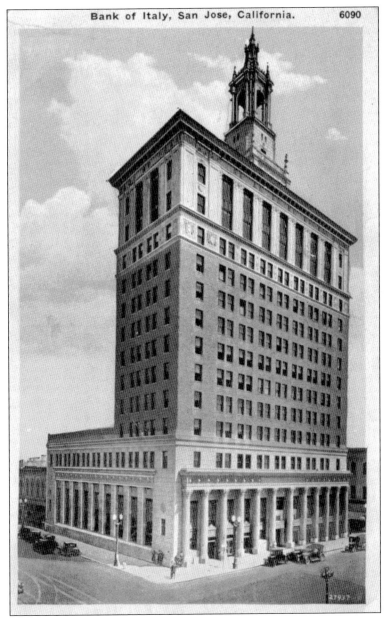

Bank of Italy, San Jose, California. 6090

In 1910, the Bank of Italy established its first branch office outside of San Francisco in San Jose, the birthplace of Bank of Italy founder and president A. G. Giannini. In 1927, the Bank of Italy constructed a 13-story building at the corner of First and Santa Clara Streets, where the San Jose Safe Deposit Bank had stood. The Bank of Italy was the tallest structure in San Jose for 61 years. Designed in the Italian Renaissance style by San Francisco architect Henry A. Minton, it was constructed and furnished with the highest quality materials. The 13-story building was topped by a five-story tower with a beacon to warn away low-flying aircraft. In 1930, the Bank of Italy changed its name to Bank of America. In the early 1990s, Bank of America moved its local headquarters to Park Center Plaza at the corner of Park Avenue and Market Street. Although no longer the tallest building in San Jose, the old Bank of Italy tower remains a downtown landmark. (Courtesy of the California Room.)

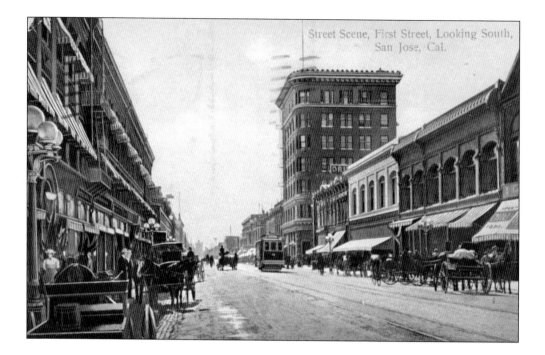

Here are two views of First Street looking south from the vicinity of Post Street. The streetcar plus an abundance of horse-drawn vehicles dates these scenes to the early part of the 20th century. In both postcards the Garden City Bank Building can be seen on the right. (Both, courtesy of the Sourisseau Academy.)

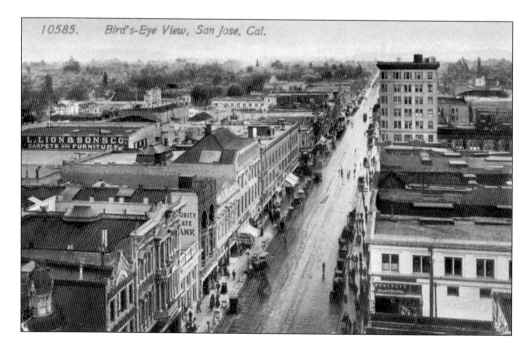

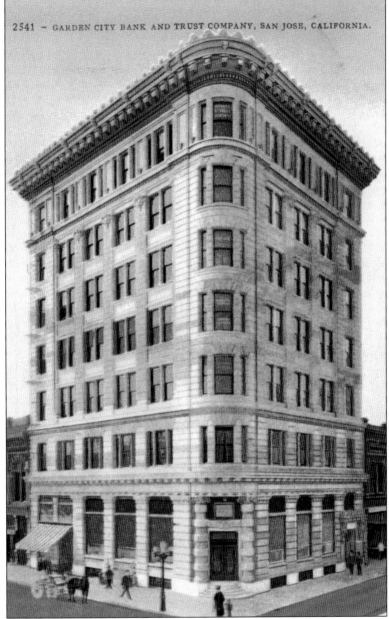

2541 – GARDEN CITY BANK AND TRUST COMPANY, SAN JOSE, CALIFORNIA.

The Garden City Bank was organized in 1887 with Dr. Charles Breyfogle as president. In 1905, the bank began constructing San Jose's first skyscraper, a seven-story steel-framed structure at the southwest corner of First and San Fernando Streets. The steel frame was in place when the 1906 earthquake hit. But little damage was done, and the bank was able to open as planned in 1907. The bank grew steadily in the 1910s, adding branches in Saratoga, Gilroy, and Campbell. In the 1920s, the Garden City Bank merged with the American Trust Company, which in 1960 became part of Wells Fargo Bank. In 1970, Wells Fargo moved to new quarters a block away in the Park Center Plaza at Market and San Fernando Streets. The old Garden City Bank Building was demolished, and the Knight Ridder building was constructed in its place. (Courtesy of the California Room.)

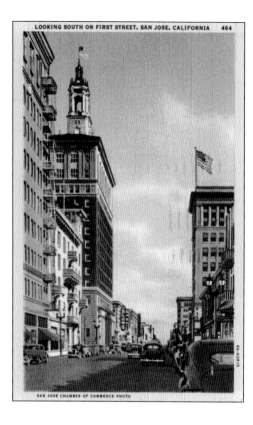

This postcard from the late 1930s shows a view looking south on First Street toward the intersection with Santa Clara Streets. At the intersection on the left are the Bank of San Jose and the towering Bank of Italy. On the right with the flagpole is the First National Bank of San Jose. No wonder the locals called this intersection "Bank Corner." (Courtesy of the California Room.)

Turn to the left from the above view and the Commercial Building comes into sight. The 10-story steel-reinforced concrete structure was erected by a group of local businessmen called the Commercial Club. It was completed in August 1926 at a cost of $425,000. During World War II, the U.S. 7th Army headquarters occupied the entire structure. It is still used for office space today. (Courtesy of the Sourisseau Academy.)

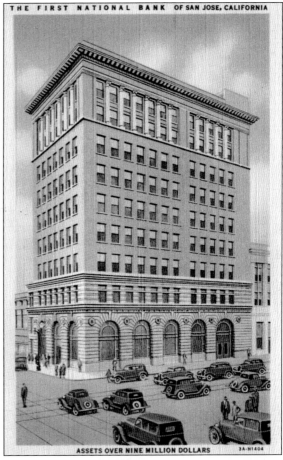

ASSETS OVER NINE MILLION DOLLARS 3A-H1404

The First National Bank of San Jose was incorporated in 1874. It opened this nine-story, $400,000 structure in January 1911 at the southwest corner of First and Santa Clara Streets. It was the tallest building in San Jose until the Bank of Italy was constructed across the street. The right one-third of the building is actually an addition constructed in 1927 at a cost of $500,000. The bank's lobby was beautifully finished with tiled floors, marble-trimmed walls, and bronze teller windows. In 1963, a two-year renovation of the bank's exterior dramatically changed the appearance of the building. The brick facade was replaced with a more modern look of glass and stone. The structure still stands at the same corner, but it appears very different from the postcard. (Both, courtesy of the California Room.)

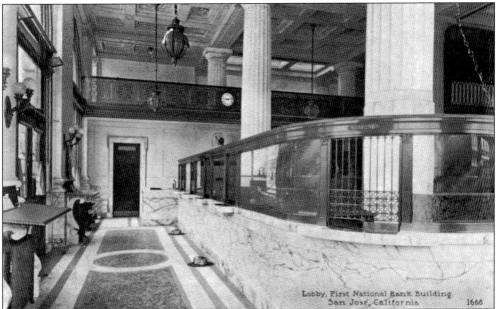

Lobby, First National Bank Building
San José, California 1666

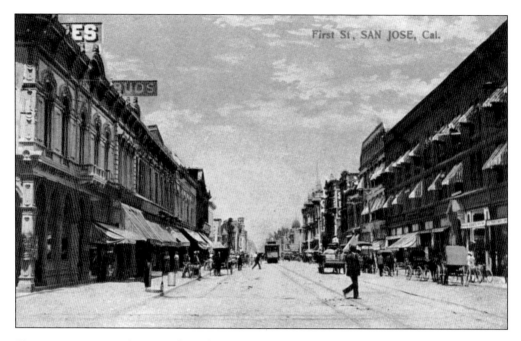

First St, SAN JOSE, Cal.

Here are two postcard views of South First Street taken about 20 years apart. The older view (above) shows South First Street looking north from the vicinity of San Fernando Street. The later view (below) again looks north on South First Street but this time from the vicinity of San Carlos Street. On the left is the sign for the Hippodrome Theater, which was built in 1919. Some people may remember it in later years as the United Artists Theater. The Montgomery Hotel now sits on part of the space once occupied by the Hippodrome. Farther up the street on the right is the Sherman Clay Music Store. (Above, courtesy of the California Room; below, courtesy of the Sourisseau Academy.)

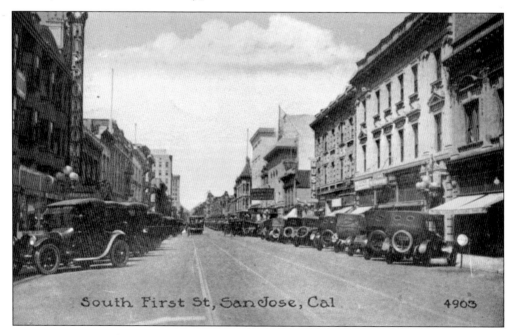

South First St, San Jose, Cal 4903

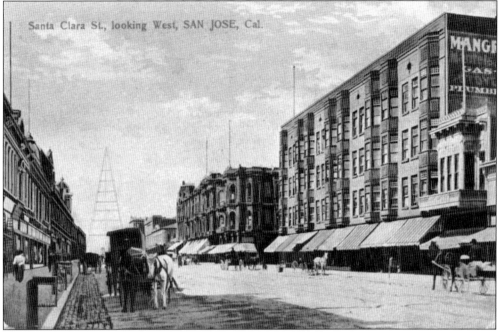

This early-20th-century view is of Santa Clara Street looking west from Third Street. The downtown landmark Electric Light Tower can be seen in the background on the left. The large structure on the right is the Porter Building. (Courtesy of the Sourisseau Academy.)

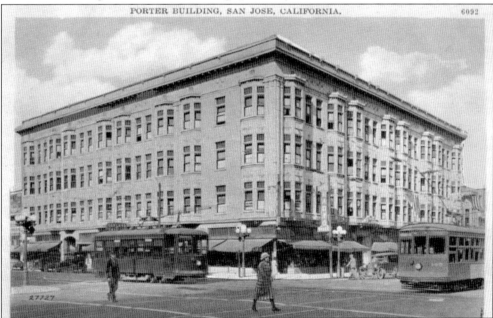

This is the Porter Building some 20 years later, after it had been expanded and renovated. The Porter Building was constructed around 1890 by Norman Porter at the northeast corner of Second and Santa Clara Streets. This was the site of the Porter family home, which was moved to East St. James Street. The Porter Building was demolished in the 1960s, and the Pacific Telephone building was constructed in its place. (Courtesy of the California Room.)

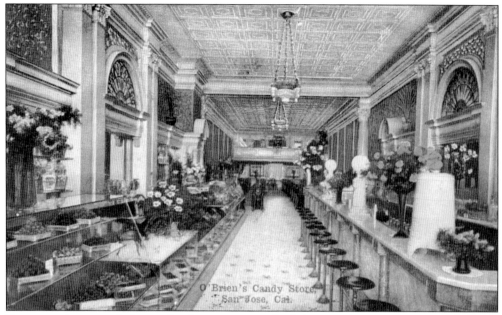

For generations, people in search of a tasty treat walked through the doors of O'Brien's Candy Store. Founded in 1868 by Maurice O'Brien, the store stood at this location at 30 South First Street from 1873 until 1928. The shop tempted customers with candy, baked goods, a soda fountain, and a restaurant. The store moved across the street in 1928 but closed in 1956, a victim of the decline of downtown San Jose. (Courtesy of the California Room.)

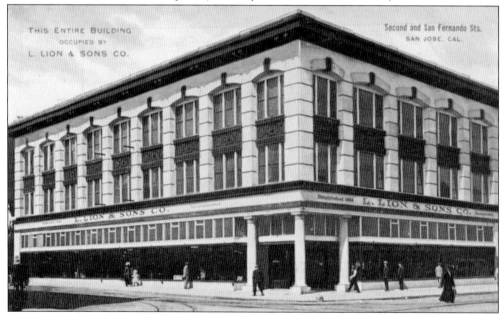

Strollers pass by the shop windows of the L. Lion and Sons Furniture Store, the largest furniture store in San Jose. Founded in 1856 by Lazard Lion, the company moved to this new building at the corner of Second and San Fernando Streets in 1908. Though L. Lion went out of business in 1967, the structure still remains, with the first floor occupied by the Gordon Biersch Brew Pub. (Courtesy of the California Room.)

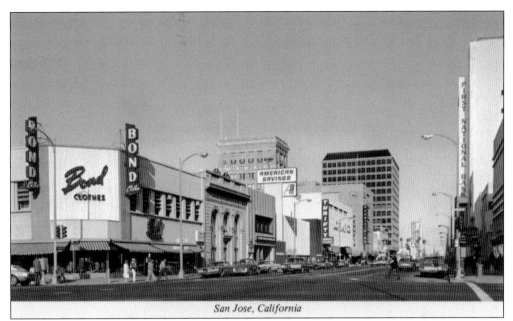

San Jose, California

The cars and pedestrians in this scene from the 1960s may disguise the fact that by this time the decline of downtown San Jose was well underway. The view is of Santa Clara Street looking east from Market Street. The top of the Commercial Building can be seen in the middle center. The tall structure to the right is the Pacific Telephone building, which replaced the Porter Building. (Courtesy of the California Room.)

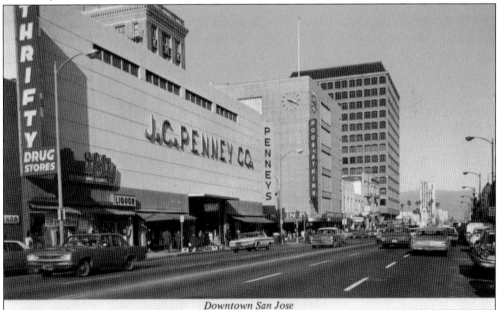

Downtown San Jose

Moving a little farther down Santa Clara Street there were two major stores anchoring the corner of First and Santa Clara Streets. The Roos Atkins Clothing Store was the first to abandon downtown San Jose in December 1972. The J. C. Penney Store stayed a little longer, closing in 1973. They joined the stream of large and small businesses leaving downtown San Jose for the busier shopping centers and malls of suburbia. (Courtesy of the California Room.)

21

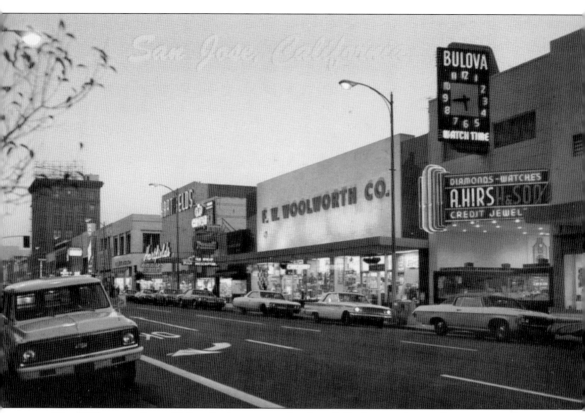

The 1970s were the twilight of a downtown San Jose full of vacant lots and empty storefronts. The Woolworth Store hung on the longest, not closing until 1997. In the last decade, downtown San Jose has undergone a renaissance. There are now high-rise residences, restaurants, nightclubs, and even grocery stores. But the department stores and small businesses that gave vitality to the heart of the city have yet to return. (Courtesy of the California Room.)

Two

HALLS OF LEARNING

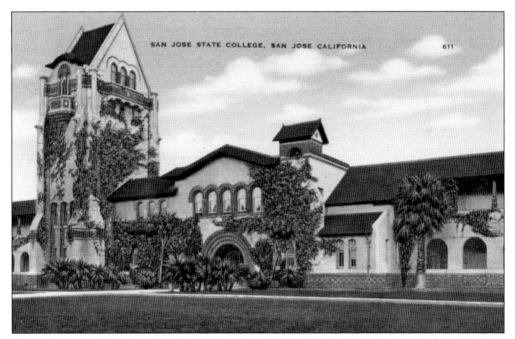

Compulsory public education in California originated in San Jose in 1795, when Mexican governor Diego de Borica ordered parents here to begin sending their children to school. Over the years, San Joseans have had access to excellent public and private schools at all grade levels, from elementary through college. Education and learning continue to be highly valued in the San Jose community. (Courtesy of the California Room.)

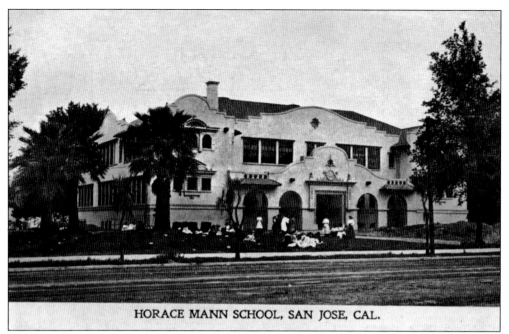

HORACE MANN SCHOOL, SAN JOSE, CAL.

Horace Mann School was built in 1907 to replace the 1868 Santa Clara Street School destroyed in the 1906 earthquake. In 1892, the school was named after Horace Mann, the famous 19th-century educator. The structure was typical of schools constructed in San Jose at this time, with two floors and a basement that housed shop classes. At the back was a dirt playground with separate play areas for girls and boys. (Courtesy of the California Room.)

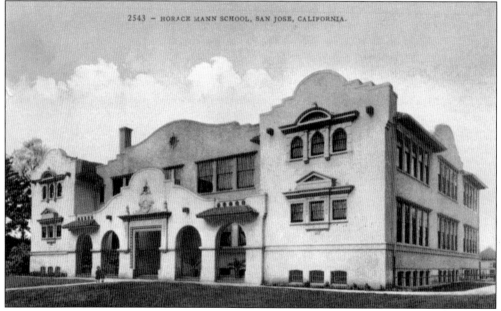

2543 – HORACE MANN SCHOOL, SAN JOSE, CALIFORNIA.

Horace Mann School stood at the corner of Sixth and Santa Clara Streets in downtown San Jose. It was demolished in 1971 after it failed to meet earthquake safety standards. Students met in cramped portable classrooms until a new Horace Mann School was opened at this site in August 2003. (Courtesy of the Sourisseau Academy.)

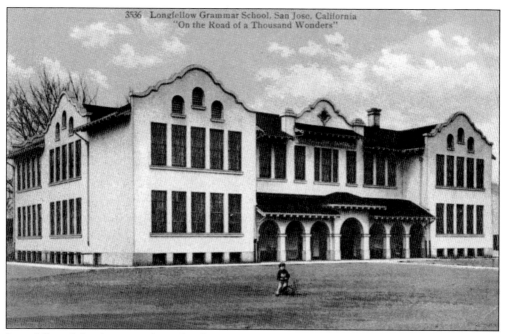

Longfellow School was another school constructed to replace an older building destroyed in the 1906 earthquake. It stood at 275 Terraine Street near North San Pedro and West Julian Streets. It was closed in the early 1970s as an earthquake hazard, and its students were transferred to Hester Elementary School. The site is now a vacant lot. (Courtesy of the Sourisseau Academy.)

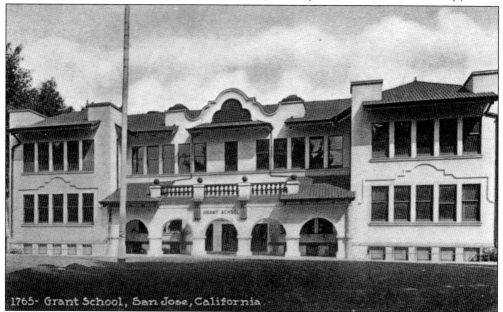

Grant School was a two-story stucco structure that stood on East Empire Street between North Tenth and North Eleventh Streets. It also was constructed to replace an older building destroyed by the 1906 earthquake. It too was demolished in the early 1970s after failing to meet earthquake safety standards. It was replaced by a new school at the corner of Jackson and Tenth Streets. (Courtesy of the California Room.)

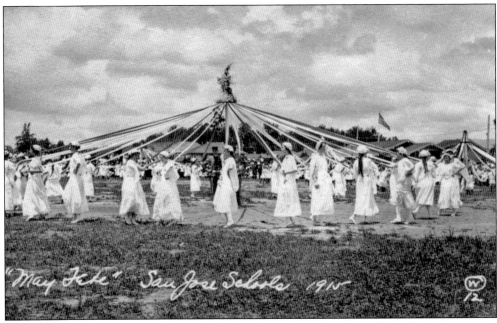

Female San Jose school students at an unknown location perform a traditional maypole dance in May 1915. (Courtesy of the California Room.)

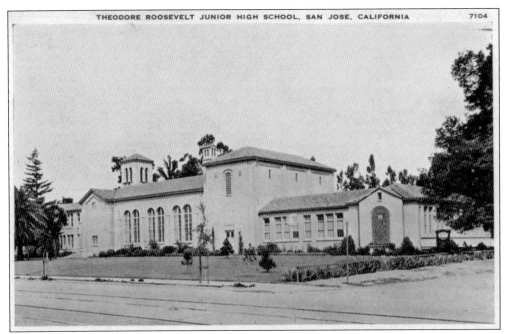

Theodore Roosevelt was San Jose's first junior high school. It was located on the grounds once occupied by the Garden City Sanitarium on the north side of East Santa Clara Street just east of Coyote Creek. It was built in 1925 and was dedicated in February 1926. (Courtesy of the Sourisseau Academy.)

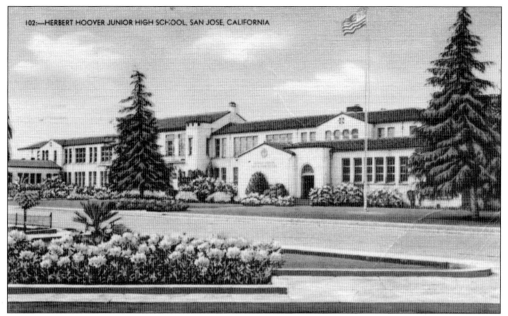

San Jose's second junior high school was built in 1931 and named after then-president Herbert Hoover. Designed by local architect William Weeks, it featured distinctive stained glass windows and tiled flooring. After its closure in 1971, the school district tried to sell the property. Declared a City Historic Landmark in 1995, it was saved from demolition through the efforts of neighborhood activists. It was restored in the late 1990s. (Courtesy of the California Room.)

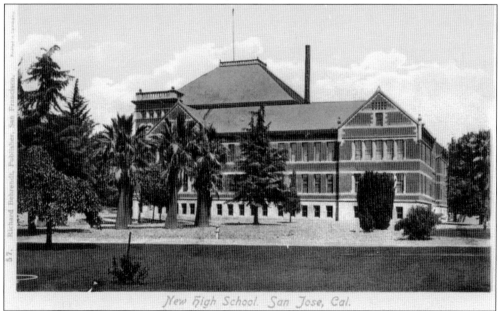

Visitors to San Jose were proudly shown the new high school, built in 1898, which was considered one of the finest in the state. The $100,000 three-story, brick-and-stone structure stood at the southwest corner of Seventh and San Fernando Streets. It was designed by Jacob Lenzen and Son and included an assembly hall that could seat up to 2,000. (Courtesy of the Sourisseau Academy.)

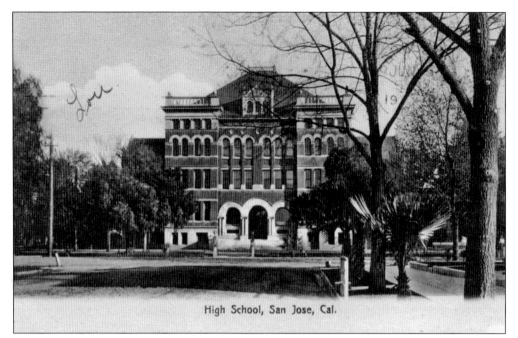

High School, San Jose, Cal.

The pride of San Jose was dealt a fatal blow early in the morning of April 18, 1906, when the great earthquake left the building in ruins. Walls collapsed, and the roof fell into the interior. If the earthquake had occurred later in the day, when school was in session, the death toll could have been horrific. Undaunted, the school board immediately began planning to construct a new high school on the site. Just six months after the earthquake, San Jose voters approved a bond measure to rebuild the high school. (Above, courtesy of the Sourisseau Academy; below, courtesy of the California Room.)

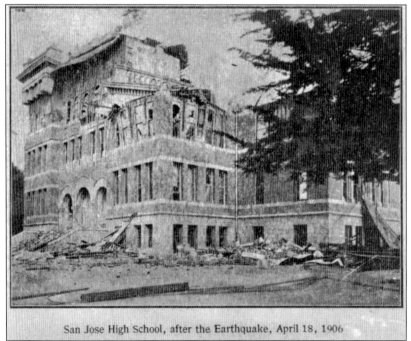

San Jose High School, after the Earthquake, April 18, 1906

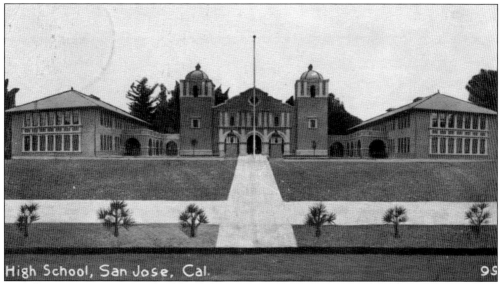

High School, San Jose, Cal. 9S

The new San Jose High School building opened on the site of the old one in September 1908. The spacious campus was spread out among five separate structures connected by arcades. Administrative offices and an auditorium occupied the center building, with its flanking bell towers. On either side of the central building were wings for the science and literature classrooms. In the rear were the domestic arts and manual arts buildings. (Courtesy of the California Room.)

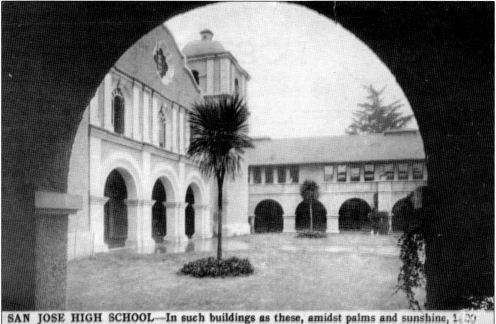

SAN JOSE HIGH SCHOOL—In such buildings as these, amidst palms and sunshine, 1,000 students receive a thorough, ready-for-college education from well-equipped instructors.

This $175,000 building was designed by F. S. Allen of Pasadena in the Mission Revival style, incorporating red tile roofs and open courtyards. The cement walls were built extra thick in the hope of resisting future earthquakes. But the expansion needs of the neighboring state college forced the closing of the school in 1952, and the campus was moved elsewhere. (Courtesy of the California Room.)

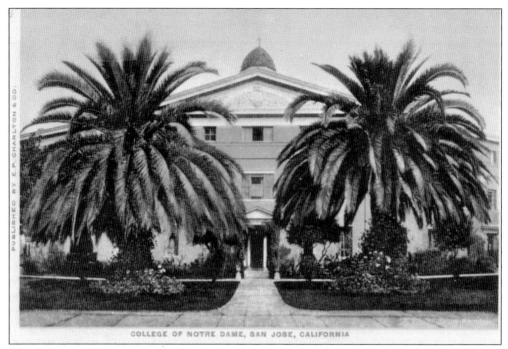

COLLEGE OF NOTRE DAME, SAN JOSE, CALIFORNIA

The College of Notre Dame was founded in 1851 by the Sisters of Notre Dame de Namur. It was the first college authorized by the State of California to grant baccalaureate degrees to women. The convent and school occupied 10 acres of land along West Santa Clara Street near downtown San Jose. The main building, with its classical entrance, was designed by Levi Goodrich and was completed in 1863. (Courtesy of the Sourisseau Academy.)

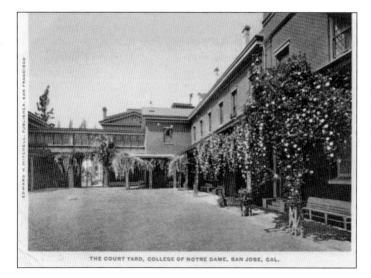

THE COURT YARD, COLLEGE OF NOTRE DAME, SAN JOSE, CAL.

The college buildings surrounded an inner courtyard lined by verandas used by students to reach their classes. The college quickly gained a reputation as the premier women's college on the West Coast. It drew students from the western United States as well as from Central and South America. (Courtesy of the California Room.)

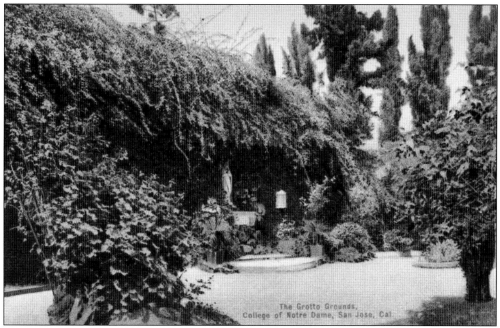

The extensive college grounds were laid out with trees, flowers, lawns, and statuary. This grotto was a replica of the famous Lourdes Grotto in France. It was erected in 1886 and was composed of serpentine and chalcedony stones mined in the Santa Cruz Mountains. (Courtesy of the California Room.)

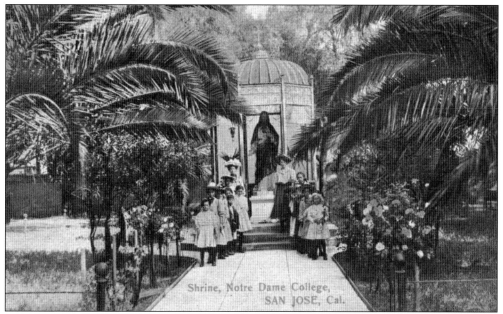

This statue of the Sacred Heart of Jesus was erected to commemorate the college's "Golden Jubilee." Increasing land values and the disruption caused by nearby downtown businesses prompted the college to move to more peaceful quarters in Belmont. The last San Jose class graduated in June 1923. All traces of the college have disappeared, and much of the land is now occupied by the Hotel De Anza. (Courtesy of the California Room.)

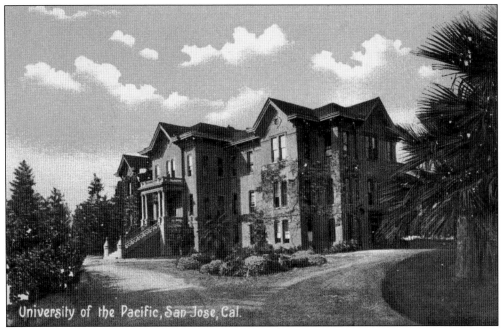

University of the Pacific was founded by Methodist ministers and laymen in Santa Clara in 1851. In 1871, it moved to the area of San Jose now known as College Park. East Hall housed the men's dormitory on the third floor and classrooms, a library, and laboratories on the other floors. It was originally four stories, but the top floor had to be removed after damage by the 1906 earthquake. (Courtesy of the California Room.)

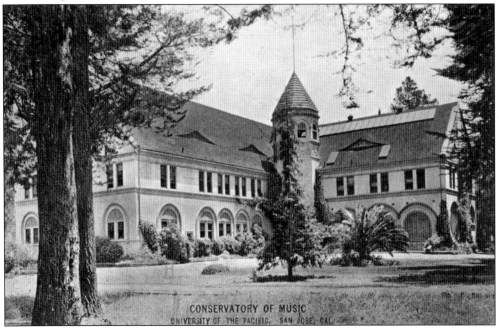

The music program was one of the largest departments in the college. The Conservatory of Music opened in 1890. The building contained a 1,000-seat auditorium as well as faculty offices and student practice rooms. (Courtesy of the Sourisseau Academy.)

Constructed in 1871, West Hall was the oldest building on the University of the Pacific campus. It was the women's dormitory as well as the university's first library. The structure was completely destroyed by fire in 1915. All the library books were lost, but staff managed to save the card catalog and the Encyclopedia Britannica. (Courtesy of the Sourisseau Academy.)

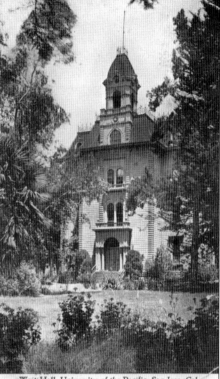

West Hall, University of the Pacific, San Jose, Cal.

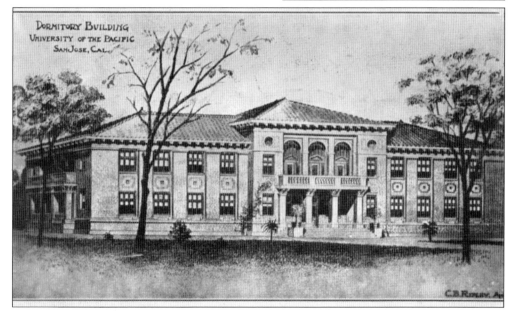

Helen Guth Hall was a new ladies dormitory built in the mission style in 1909. It was named in honor of the wife of William Wesley Guth, president of the University of the Pacific from 1908 through 1913. In 1925, University of the Pacific moved to Stockton, and the campus was acquired by Bellarmine Preparatory School. Helen Guth Hall was demolished in 1997. (Courtesy of the Sourisseau Academy.)

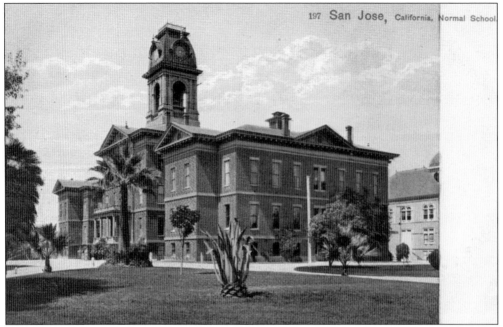

San Jose State Normal School was founded in 1871 to train teachers for California's public schools. This brick building was designed by local architect Levi Goodrich. It was constructed in 1881 to replace an earlier wooden structure destroyed by fire. It was severely damaged in the 1906 earthquake and had to be demolished. (Courtesy of the California Room.)

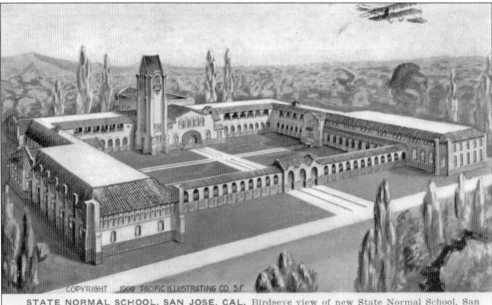

STATE NORMAL SCHOOL, SAN JOSE, CAL. Birdseye view of new State Normal School, San Jose, Cal., the finest Normal School in this country, which cost the State of California $325,000. It numbers over 700 students and has a faculty of thirty-four. President, Morris Elmer Dailey.

The state legislature approved $325,000 to rebuild the normal school after the 1906 earthquake. The reinforced-concrete structure was constructed in the form of a quadrangle. A writer for the *San Jose Mercury* wrote, "The building's style is the Art Nouveau, and combining the Moorish, Gothic, Spanish, Renaissance and Mission Schools." (Courtesy of the California Room.)

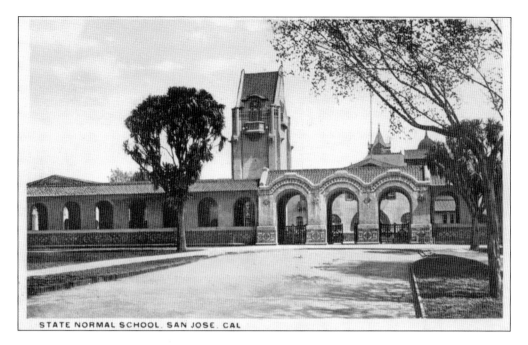

STATE NORMAL SCHOOL. SAN JOSE. CAL

The new school opened on September 20, 1910, with an enrollment of 600 students. On the evening of September 23, 1910, an open house was held, attended by an estimated 15,000 people. Visitors entered through the main gate on Fourth Street (above). Once in the quadrangle (below) they were surrounded by structures that included classrooms, a library, an auditorium, and a tower. At the time of its construction, San Jose State Normal School was the largest reinforced-concrete building in the world. (Both, courtesy of the Sourisseau Academy.)

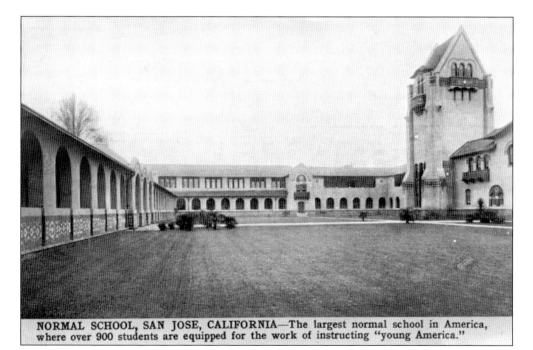

NORMAL SCHOOL, SAN JOSE, CALIFORNIA—The largest normal school in America, where over 900 students are equipped for the work of instructing "young America."

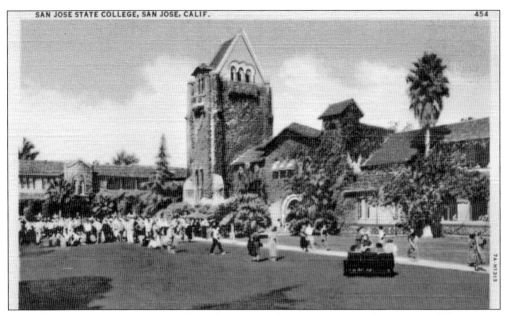

With its expansive lawns, the quadrangle became the social center of campus and the setting for graduations and other ceremonies. In 1921, San Jose State Normal School became San Jose State Teachers College. In 1935, the word "Teachers" was dropped, and the school was known as San Jose State College. Student enrollment grew steadily in the 1920s and 1930s, and then accelerated sharply in the postwar years, as returning soldiers took advantage of the G.I. Bill to go back to school. The campus expanded and changed to meet the needs of the growing student population. To reflect its enhanced educational role, San Jose State College was granted university status in 1972, and in 1974, its name was changed to San Jose State University. (Above, courtesy of the Sourisseau Academy; below, courtesy of the California Room.)

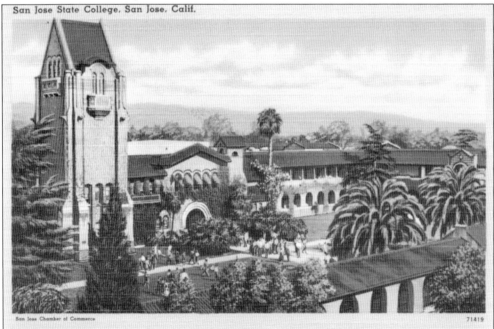

San Jose State College, San Jose, Calif.

San Jose Chamber of Commerce 71419

After years in cramped temporary quarters, students voted to assess themselves additional fees in order to build a new student union in November 1963. The $3.24-million building was designed by E. J. Kump Associates, the same firm that designed Foothill College. The 135,000-square-foot structure had a concrete, brick, and wood-trim exterior and a three-level interior featuring a lounge area on each floor. (Courtesy of the Sourisseau Academy.)

The $4.3-million Business Tower housed the offices and classroom of the College of Business. The building was dedicated on May 4, 1973, with a speech by John DeLorean, then a recently retired General Motors executive and later founder of DeLorean Motor Company. (Courtesy of the Sourisseau Academy.)

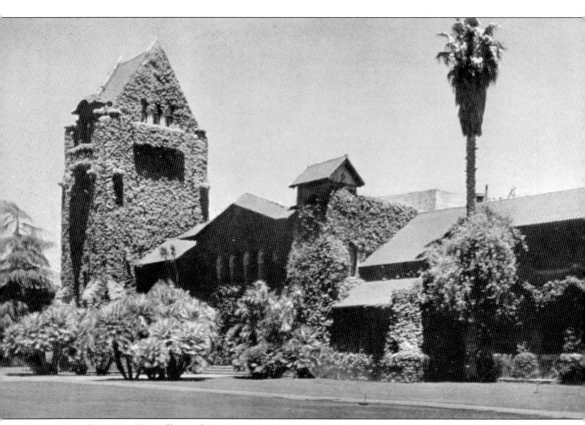

In March 1963, the Office of the State Architect released a report condemning Tower Hall for not being earthquake-safe and recommending that the tower and adjacent Morris Daily Auditorium be torn down. This caused an outcry among students, faculty, alumni, and concerned citizens, who saw the tower as a symbol of the university worth preserving. The Student Body Association sent a 50-foot telegram of concern with 5,000 names to Gov. Pat Brown and to California assembly speaker Jesse Unruh. Their efforts were rewarded when $757,724 was allocated by the state legislature in 1965 to renovate Tower Hall. But while the tower was saved, the quadrangle arcade and other buildings fell victim to the wrecker's ball. Today Tower Hall and the Morris Dailey Auditorium are the only survivors of the 1910 construction. (Courtesy of the California Room.)

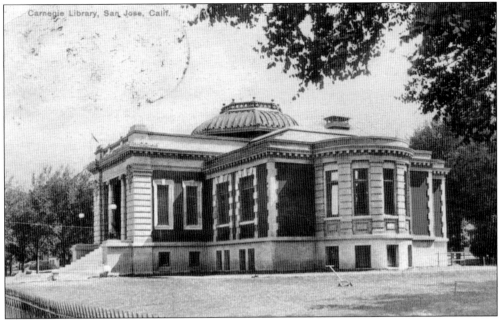

In 1901, Andrew Carnegie gave the City of San Jose $50,000 to construct a new library to replace the old one housed in city hall. The new library opened to the public on June 1, 1903. The brick and sandstone building was located at the corner of Fourth and San Fernando Streets next to the San Jose State Normal School campus. The front steps led into a lobby covered by a copper dome with reading rooms on both sides and a separate area for children. The new structure opened with 14,000 books, but within five years, it had outgrown the space. The library was unable to find new quarters until 1937, when it moved into the old post office on Market Street. The Carnegie Library was bought by San Jose State University and was used as a student union until it was demolished in 1960. (Both, courtesy of the California Room.)

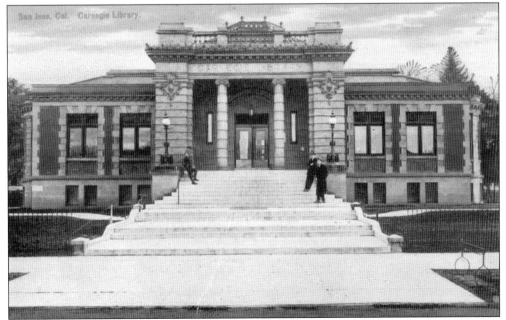

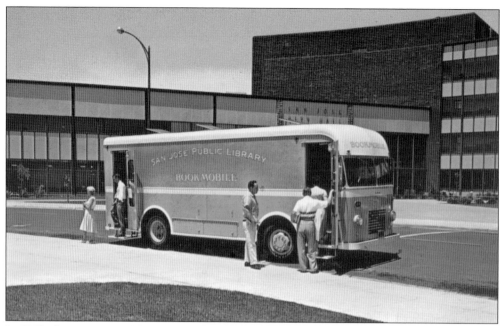

In 1959, the San Jose Public Library purchased its first bookmobile in order to better serve the city's growing population. The 22-foot bookmobile held 4,000 volumes. Here it is parked in front of the San Jose City Hall, located on Mission Street. (Courtesy of the California Room.)

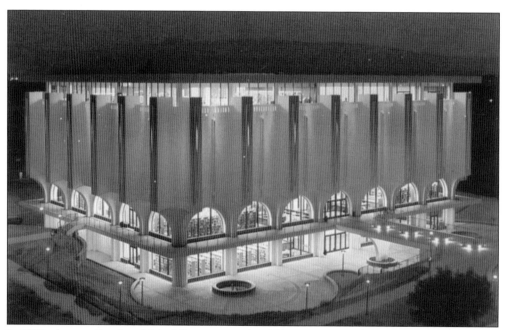

In 1970, the new San Jose Main Library opened at 180 West San Carlos Avenue across from the Civic Auditorium. In 1990, the main library was rededicated in honor of Dr. Martin Luther King Jr. In August 2003, the library was moved into a joint city/university library at San Jose State University. Ironically the new library is located at the very spot where the Carnegie Library was built some 100 years prior. (Courtesy of the California Room.)

Three

SIGHTS AND DIVERSIONS

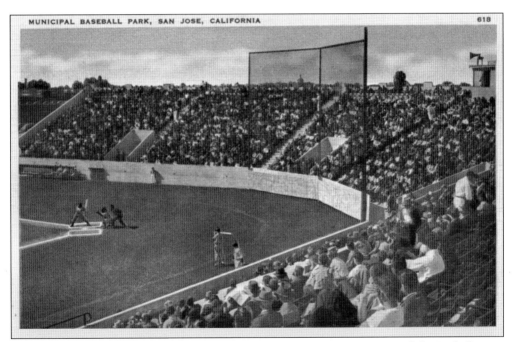

San Jose has always offered its residents a wide variety of things to see and do, including an afternoon baseball game at the San Jose Municipal Stadium. The concrete stadium was built in the early 1940s as a Works Progress Administration (WPA) project for $80,000. It is now the home of the San Jose Giants, a Class A Minor League team affiliated with the San Francisco Giants since 1988. (Courtesy of the Sourisseau Academy.)

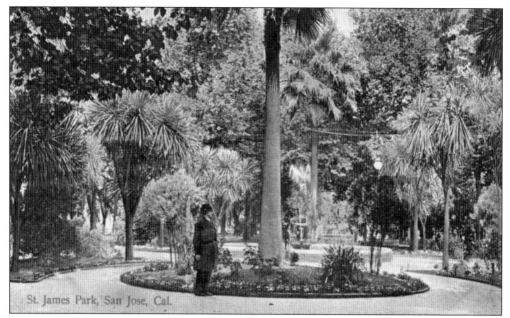

St. James Park, San Jose, Cal.

The unidentified police officer admiring this palm tree in St. James Park may also be giving thanks to Chester Lyman. When Lyman surveyed the small pueblo in 1848 he had the foresight to include three public squares in his plan, including St. James. After years of neglect, the construction of the Santa Clara County Courthouse and St. James Hotel across the street prompted the city to develop the square into a park. (Courtesy of the Sourisseau Academy.)

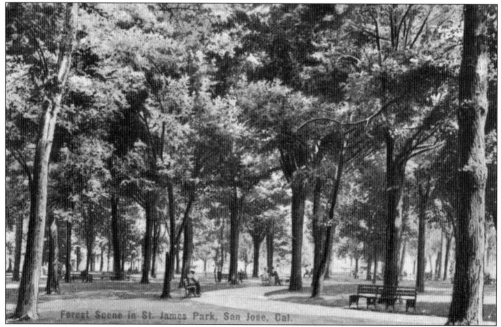

Forest Scene in St. James Park, San Jose, Cal.

The park occupied the equivalent of two city blocks. While not totally avoiding lawns and flower beds, early park planners made a decision to plant mostly trees in the park. The intention was to give the feeling of a forest glade in the middle of the city, where visitors could walk the meandering paths or rest on one of the benches. (Courtesy of the California Room.)

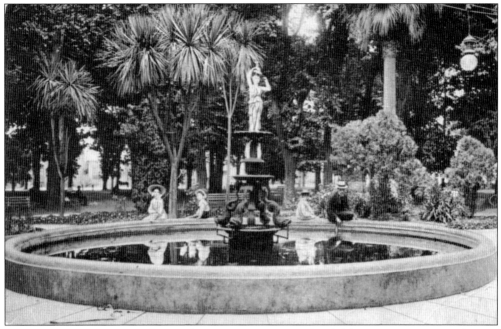

The fountain in the center of the park was a great attraction for children. It was constructed in the 1890s and was stocked with goldfish. The park became increasingly popular, as it was surrounded by churches and public buildings. The natural unity of the park was badly compromised in 1955, when politicians and merchants decided to extend Second Street through the middle of the park, effectively cutting it in half and forcing the demolition of the fountain. In 1977, St. James Park and the buildings around its border were added to the National Register of Historic Places, helping preserve its remaining character for future generations. (Above, courtesy of the California Room; below, courtesy of the Sourisseau Academy.)

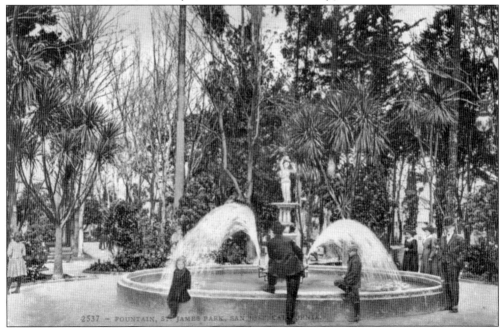

2537 – FOUNTAIN, ST. JAMES PARK, SAN JOSE, CALIFORNIA.

Winter Scene, St. James Park, San Jose, Cal.

In 1894, an editorial in the *San Jose Evening News* complained about how the serenity of St. James Park was being ruined by "the tramps and bums who find a safe haven of rest on the benches." The editor asserted that such people were offensive to the ladies and children using the park. Such social problems still plague St. James Park 125 years later, as park users often must deal with drunks, drug users, the homeless, and panhandlers. (Courtesy of the California Room.)

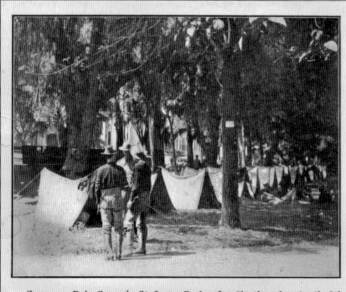

Company B in Camp in St. James Park, after Earthquake, April 18th.

During the 1850s and 1860s, St. James Square was often used as a drill field for local militia. Soldiers reappeared in the park after the 1906 earthquake, when Company B of the local National Guard was mobilized to prevent looting and to enforce a curfew. As days passed and things calmed down, the park became quite popular for locals to stop by around 10:00 a.m. to observe the daily inspection and drill. (Courtesy of the California Room.)

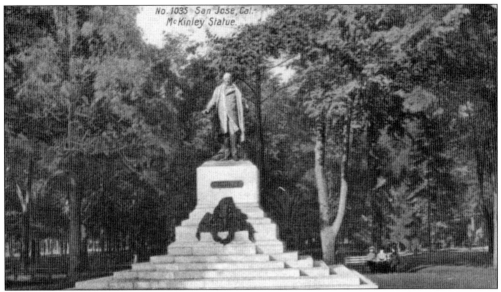

An excited city extended a lavish welcome to Pres. William McKinley when he visited San Jose on May 13, 1901. Flags and patriotic banners hung along the streets, as the president rode in a carriage from the railroad station to St. James Park. From a flower-decorated platform set up opposite the St. James Hotel, McKinley spoke to an enthusiastic crowd of 10,000. Imagine the shock that must have reverberated through San Jose when only six months later McKinley was killed by an assassin's bullet. A grieving population decided to erect a statue in his honor. Money was raised, totaling $14,000, to purchase a bronze statue on a granite base showing McKinley striding forward with his right hand slightly raised. The statue was dedicated on February 21, 1903, on the very spot in St. James Park where McKinley had spoken a year and a half earlier. (Both, courtesy of the California Room.)

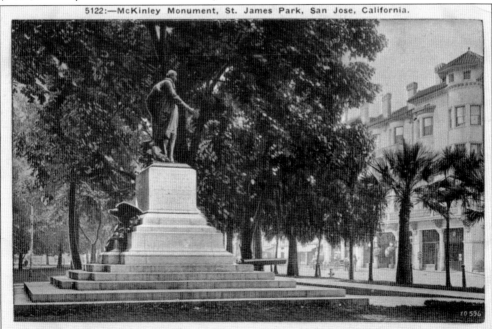

5122:—McKinley Monument, St. James Park, San Jose, California.

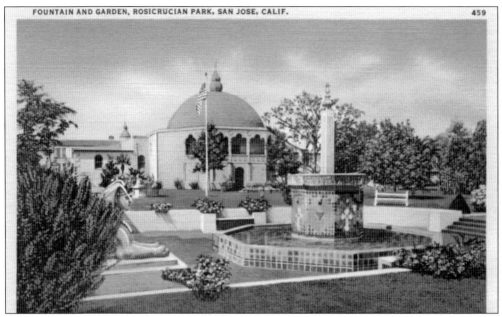

A bit of the exotic Middle East came to San Jose in the 1930s when the Rosicrucian Order, AMORC, decided to locate its Grand Lodge here. The order purchased an entire city block at Naglee and Park Avenues, which was developed into Rosicrucian Park. The landscape and architecture reflected the order's origins in ancient Egypt. (Courtesy of the California Room.)

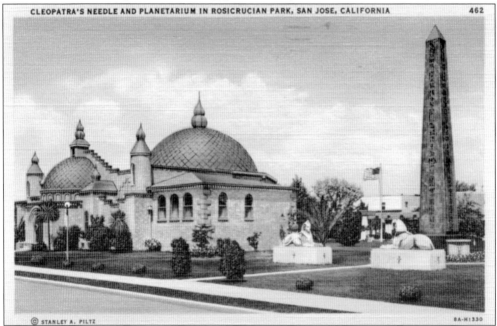

A pair of sphinx flank the path leading to a three-quarters reproduction of an obelisk (right) discovered standing before the Temple of the Sun in Heliopolis, Egypt. The Moorish-inspired architecture of the Rosicrucian Planetarium (left) is a departure from most of the architecture in the park. The planetarium was built in 1936 and was the first in Northern California. It seats 98 people under its 40-foot dome. (Courtesy of the California Room.)

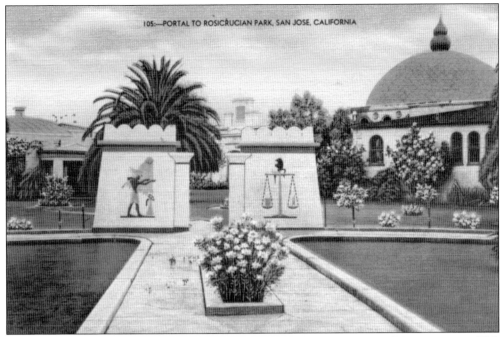

The Rosicrucian Order encourages spiritual growth through the study of the mysteries of life and the universe. The grounds of the park are open to all as a place of peaceful contemplation and urban retreat. (Courtesy of the California Room.)

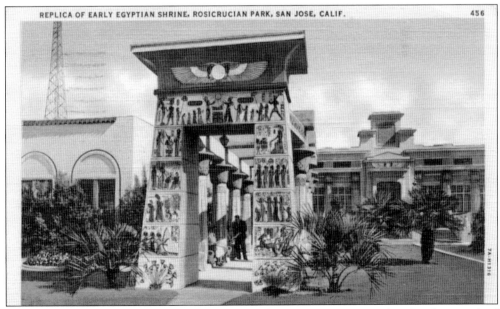

REPLICA OF EARLY EGYPTIAN SHRINE, ROSICRUCIAN PARK, SAN JOSE, CALIF. 456

The gate and pillars in the middle are a replica of an early Egyptian shrine found at the Temple of Karnak. On the right is the Rosicrucian Science Building. (Courtesy of the California Room.)

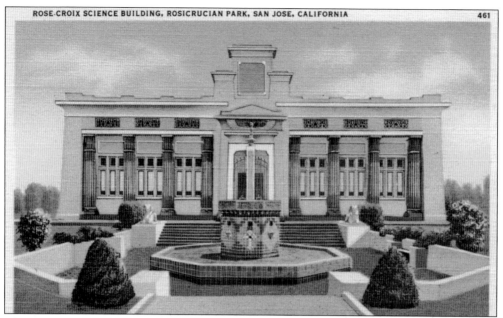

The Rosicrucian University and Science Building was opened in 1934. It contains classrooms and laboratories used for teaching the principles of the Rosicrucian Order. In 1939, the science building was expanded with the addition of a research library. Two sphinxes flank the steps leading to the science building. The sphinx on the right contains a scroll listing the 15 mystic principles important to the Rosicrucian Order. (Courtesy of the Sourisseau Academy.)

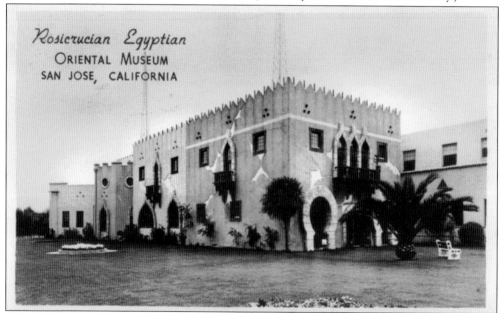

Rosicrucian Egyptian
ORIENTAL MUSEUM
SAN JOSE, CALIFORNIA

The Rosicrucian Egyptian Museum opened in 1932 to display artifacts acquired by Harvey Lewis, the founder of the order. As the collection grew through purchases and donations, more space was needed. A larger museum opened in 1966. It is a popular local attraction whose displays of mummies and other antiquities continue to fascinate both children and adults. (Courtesy of the Sourisseau Academy.)

The Electric Light Tower was the brainchild of *San Jose Mercury* publisher J. J. Owen. His idea was to illuminate downtown San Jose by mounting newly invented electric lights on a high tower. The citizens of San Jose enthusiastically embraced this use of the new technology, and enough donations poured in to begin its construction. The tower was built of iron pipe. It was placed at the intersection of Market and Santa Clara Streets, which was wide enough to provide sufficient space for the tower's feet. The tower was 207 feet tall with a 30-foot flagpole. A platform at the top held six powerful carbon arc lamps. A protective shield over the lamps helped direct the light onto the street below. This monument to progress was first lit on the evening of December 13, 1881. (Both, courtesy of the California Room.)

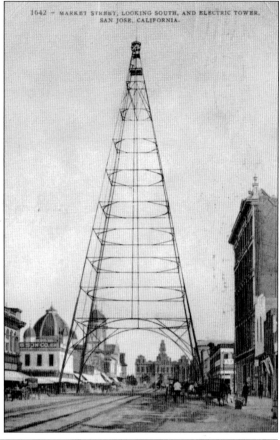

1642 – MARKET STREET, LOOKING SOUTH, AND ELECTRIC TOWER, SAN JOSE, CALIFORNIA.

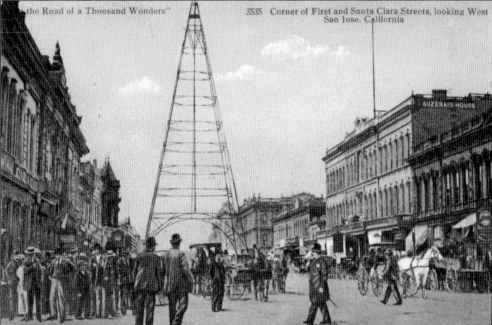

..the Road of a Thousand Wonders"

3535 Corner of First and Santa Clara Streets, looking West San Jose, California

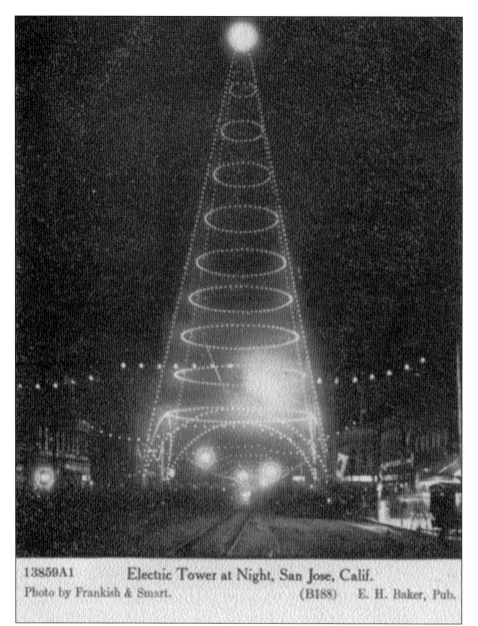

13859A1 Electric Tower at Night, San Jose, Calif.
Photo by Frankish & Smart. (B188) E. H. Baker, Pub.

When the 24,000-candlepower lamps were lit, it was as if a full moon had suddenly appeared. A man on the campus of the state normal school claimed there was enough light to read a newspaper. A farmer in Los Gatos claimed the light from the tower was keeping his chickens awake. People from as far away as Morgan Hill and Pacheco Pass claimed they could see the light at night. Eventually thousands of incandescent lights were added to the tower's support beams, giving it the appearance of a Christmas tree. Banners were hung on festive occasions, and fireworks were shot from the structure on the Fourth of July. The Electric Light Tower became a symbol of a progressive San Jose. But the elements and the passage of time took their toll. On December 3, 1915, a storm with 56-mile-per-hour winds proved too much for the tower. It collapsed into the street below. No one was hurt, but the structure was a complete wreck. Today the tower lives on as a half-size replica on the grounds of History San Jose. (Courtesy of the California Room.)

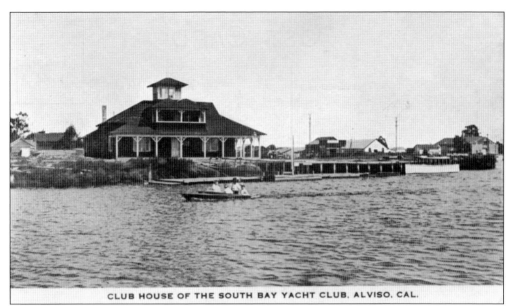

CLUB HOUSE OF THE SOUTH BAY YACHT CLUB, ALVISO, CAL.

The South Bay Yacht Club was formed in 1888 by a group of local businessmen and boating enthusiasts. In 1903, this redwood clubhouse was built on the shores of Alviso Slough. Ground subsidence eventually caused the clubhouse to sink 15 feet below sea level. In 1983, it was moved 100 yards to the north onto a levee at the corner of Hope and Catherine Streets. (Courtesy of the California Room.)

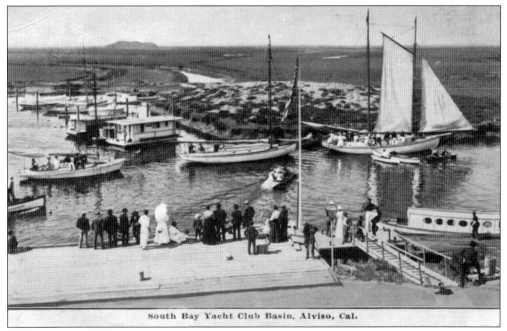

South Bay Yacht Club Basin, Alviso, Cal.

In this view from the clubhouse, boats are leaving for a regatta on San Francisco Bay. The club has always appealed more to working class sailors than to the yachting elite. Over the years, silt and freshwater weeds have choked the channels leading out into the bay, making it difficult for boats to enter or leave, even during high tide. (Courtesy of the California Room.)

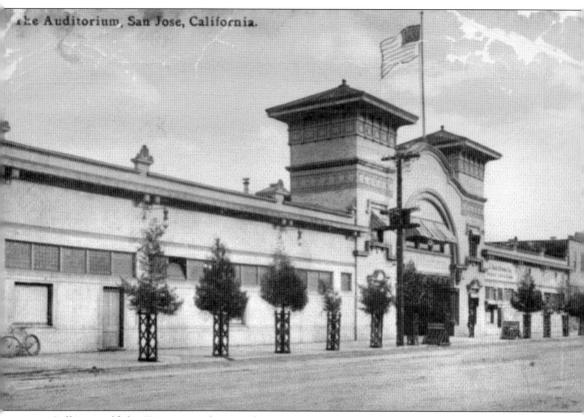

The Auditorium, San Jose, California.

Calling itself the "Finest Pavilion in the State," the Auditorium Rink was built in 1909. It occupied 200 feet on the east side of Market Street between San Carlos and San Antonio Streets. Besides roller-skating, the 32,000-square-foot main floor played host to bicycle races, dance contests, basketball games, flower shows, and poultry exhibitions. In 1909, it housed San Jose's first auto show, where thousands of visitors wandered among $500,000 worth of automobiles while being entertained with musical selections from Brohaska's Orchestra. Despite the efforts of management, the rink was not a financial success. It closed in 1918, a little less than a decade after it opened. It is now the site of the Casa del Pueblo retirement community. (Courtesy of the California Room.)

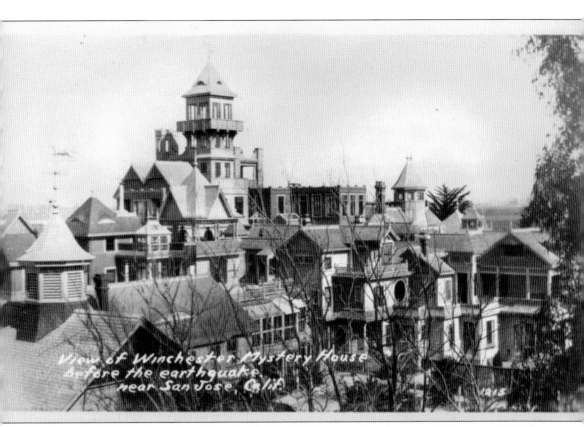

In 1884, Sarah Winchester bought an unfinished eight-room farmhouse on 44 acres outside of San Jose on what is now Winchester Boulevard. Winchester was a widow from New Haven, Connecticut, whose only child had died shortly after birth. As sole heir to the Winchester Rifle Company fortune, Winchester did not lack for money. She must have found her initial efforts to expand and remodel the farmhouse satisfying, because she did not stop making new additions to the house until her death 38 years later. Her efforts left a sprawling 160-room mansion with 40 bedrooms, 13 bathrooms, 9 kitchens, 47 fireplaces, 3 elevators, and 2 ballrooms. She lived here alone except for a private secretary, 18 servants, 8 gardeners, and 2 chauffeurs. She also employed a permanent staff of 13 to 20 carpenters for her ongoing building projects. The postcard shows the mansion at its height, when it rose seven stories prior to the 1906 earthquake. The earthquake destroyed the top three stories of the central tower, which was never rebuilt. (Courtesy of the California Room.)

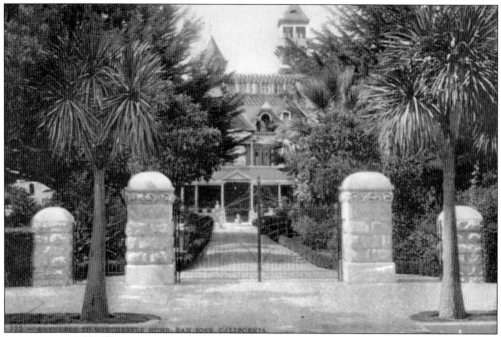

Beyond these gates lay Sarah Winchester's mansion and gardens. Winchester became more reclusive as she grew older and her health deteriorated. There is a story that she refused to admit Theodore Roosevelt when the president came to call at her front door. As with many other stories told about Winchester, there is no evidence this actually occurred. (Courtesy of the California Room.)

Winchester loved to spend time in her gardens, which were landscaped with plants from all over the world. When crippling arthritis severely limited her mobility, she was forced to spend more time inside her mansion and less in her beloved gardens. (Courtesy of the Sourisseau Academy.)

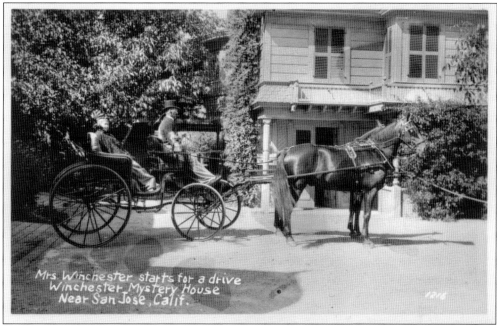

Mrs. Winchester starts for a drive
Winchester Mystery House
Near San Jose, Calif.

Winchester enjoyed taking drives in her carriage and automobiles. She did not remain aloof on her drives but would wave at passersby. After driving to downtown San Jose, her vehicle would park at the curb outside stores. Since her arthritis made walking difficult, merchants would bring out goods for her to examine. Winchester was self-conscious about her appearance and did not want her picture taken. This photograph of her in her carriage was secretly taken by one of her employees. However, the statement that this is the only known portrait of her in existence is not correct. There exists at least one other photograph of her, taken as a young woman in her hometown of New Haven, Connecticut. (Both, courtesy of the California Room.)

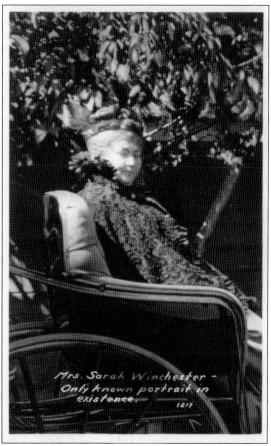

Mrs. Sarah Winchester -
Only known portrait in
existence.

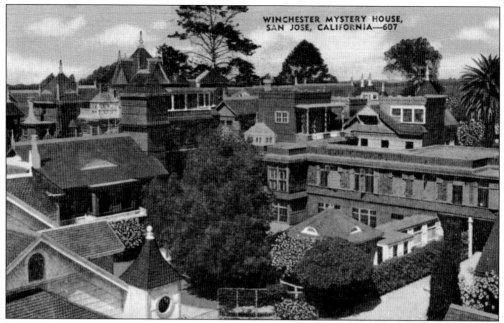

After Winchester's death in 1922, the mansion was sold to a local businessman for $135,000. It was renamed the Winchester Mystery House and was successfully marketed as a local tourist attraction. For many years the owner and the local chamber of commerce played up some of the more dubious stories about Winchester in order to attract visitors. The most common story was that a medium had told Winchester that she must keep constructing in order to appease the ghosts of all those killed by Winchester rifles. As long as she kept building, she would never die. In truth, Winchester was probably an eccentric amateur builder wealthy enough to indulge her unusual hobby. The fact that today people make special trips to visit the mansion she constructed would no doubt astonish her. (Both, courtesy of the California Room.)

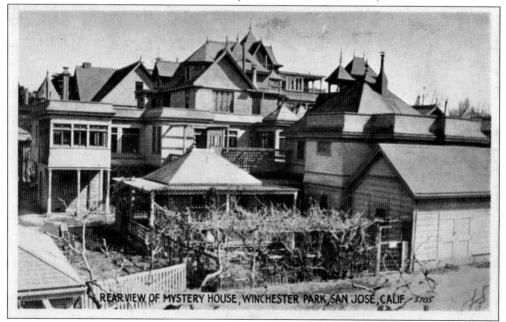

REAR VIEW OF MYSTERY HOUSE, WINCHESTER PARK, SAN JOSE, CALIF.—5705

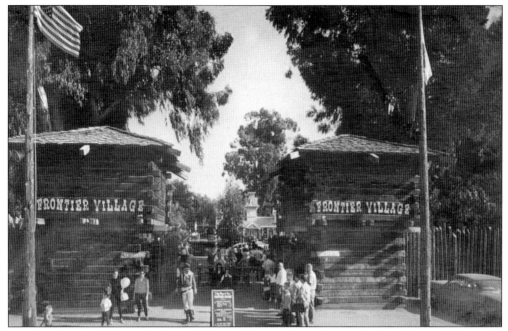

The mention of Frontier Village is sure to bring up fond memories from anyone living in San Jose in the 1960s and 1970s. The Wild West–themed amusement park opened on October 21, 1961, on 33 acres that were once part of the Hayes Mansion estate on Monterey Road in south San Jose. Admission was 90¢ for adults, 45¢ for children over 12, and no charge for children under 12. The park's blockhouse entrance led to the town square, with its Victorian-style train station. The train's 1 mile of track wound its way through the "badlands" of the park and through the Teetering Tunnel. And there was always the possibility of Wild Bill Kelsey or some other outlaw staging a train robbery. (Both, courtesy of the Sourisseau Academy.)

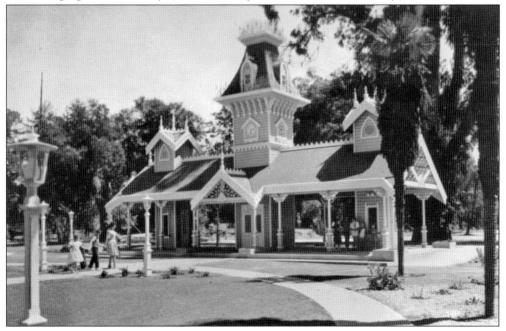

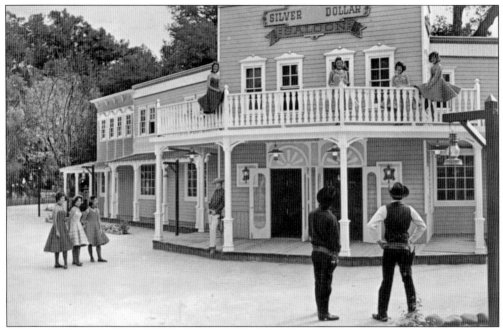

Cancan dancers pose in front of the Silver Dollar Saloon on Frontier Village's Main Street. Inside the saloon there was a piano player and a restaurant serving hamburgers and other fast food. (Courtesy of the Sourisseau Academy.)

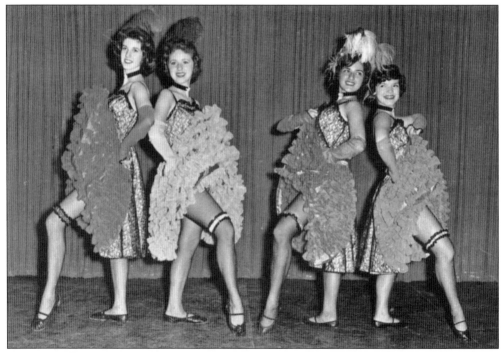

Dancers performed daily in the Silver Dollar Saloon. (Courtesy of the Sourisseau Academy.)

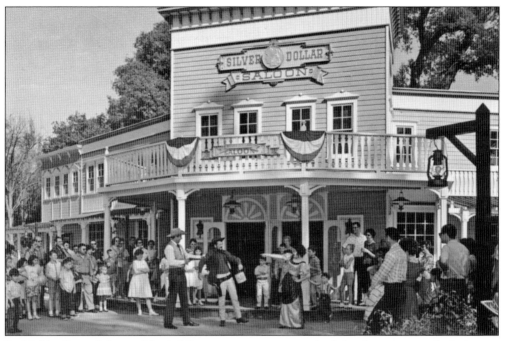

In this bit of staged drama, Marshal Ron prepares to arrest an inebriated customer at the insistence of Diamond Lil, a singer at the Silver Dollar Saloon. (Courtesy of the Sourisseau Academy.)

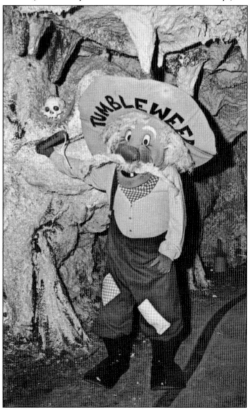

Tumbleweed the gold miner was one of the costumed characters at Frontier Village. He could often be found working the Lost Dutchman Mine. Other characters were Theodore the Bear and Kactus Kong, a lime-green ape wearing a cowboy hat. They would roam the park and interact with visitors. During the last years of the park, they were joined by six Hanna-Barbera cartoon characters, including Yogi Bear and Fred Flintstone. (Courtesy of the Sourisseau Academy.)

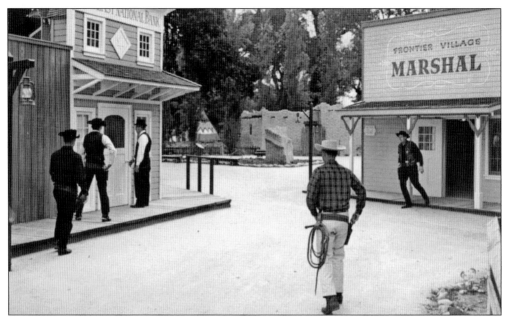

The Frontier Village experience was enlivened by gunfights staged by park employees. There were a number of scripted scenes that could take place at various locations within the park. In this scene, an unhappy banker in a top hat is being forced by Jesse James and his gang to open the Last National Bank. Meanwhile Marshal Ron is rushing from his office to foil the robbery and subdue the bad men. (Courtesy of the Sourisseau Academy.)

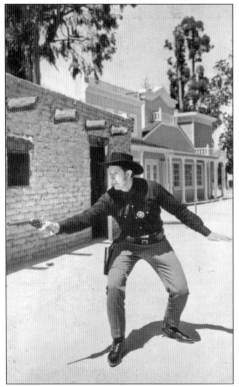

Marshal Ron draws and fires, stopping an attempted robbery by outlaws of the Last National Bank. (Courtesy of the Sourisseau Academy.)

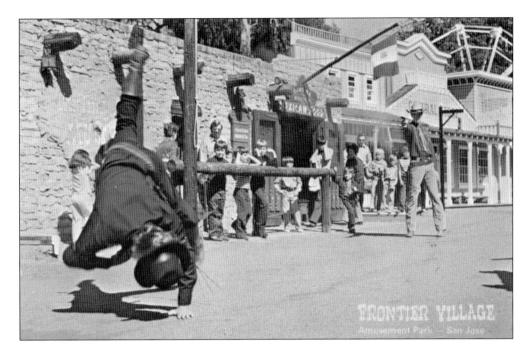

And another outlaw bites the dust! Marshal Westin handles a bad guy outside the Cantina Murrieta Café. All such confrontations were scripted and rehearsed by park staff. And they all carried the same message: "Crime Does Not Pay!" After a meeting with the marshal and his deputies the bad guy either ran away or was carted off in a wheelbarrow to Boot Hill. The pistols used during the gunfights were authentic replica Colt .45 six-shot revolvers loaded with black powder blanks. (Both, courtesy of the Sourisseau Academy.)

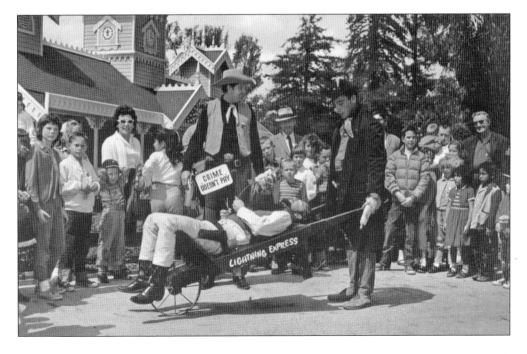

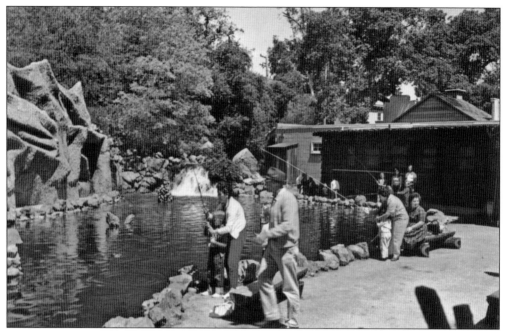

Young fishermen could try their luck at the Rainbow Falls fishing pond, which was stocked with trout. Any fish an angler caught was cleaned, bagged, and kept refrigerated until the visitor was ready to leave. (Courtesy of the Sourisseau Academy.)

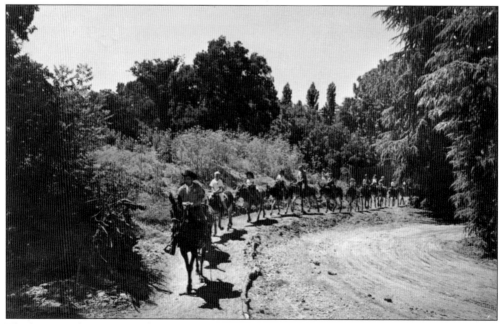

The burro pack train wound its way through the park among trees and shrubs originally planted on the grounds of the Hayes Mansion. (Courtesy of the Sourisseau Academy.)

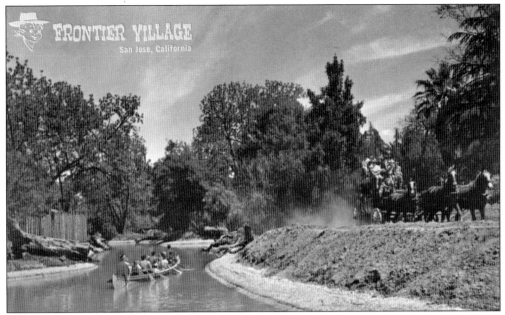

Visitors paddle a 32-foot Indian war canoe while the Frontier Village stagecoach passes nearby. Everyone in the canoe received an oar, but park employees paddling in the front and back made sure the canoe got where it was supposed to go. When water was first added to the canoe ditch after construction it kept draining into the dry soil. The problem was solved by lining the ditch with cement. (Courtesy of the Sourisseau Academy.)

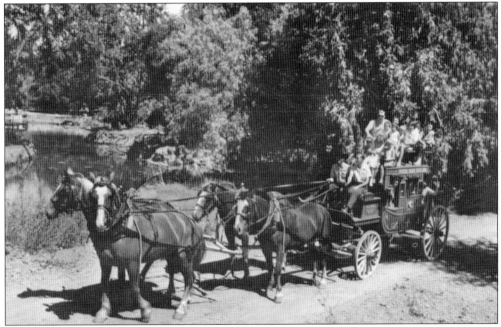

For a real Western adventure, park visitors could ride the Frontier Village stagecoach. The coach was built in Canada and was a replica of the Concord stagecoach used in the Old West. It was so authentic, passengers would complain of the hard seats and bumpy ride. (Courtesy of the Sourisseau Academy.)

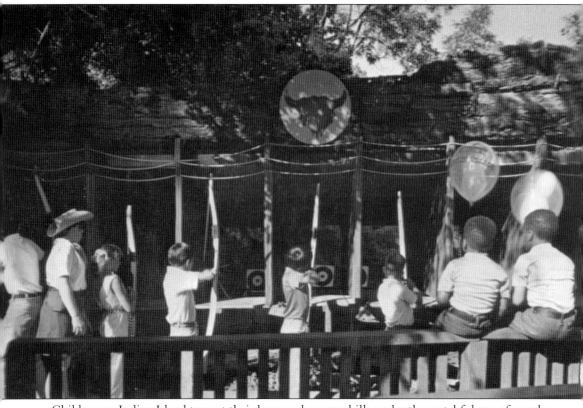

Children on Indian Island try out their bow-and-arrow skills under the watchful eye of a park employee. Despite the popularity of these kinds of attractions, Frontier Village faced a major challenge when the 85-acre Great America Theme Park opened in 1976 in nearby Santa Clara. The owners of Frontier Village knew the park had to expand in order to survive and remain competitive. They were prepared to add another 60 acres to the park. But efforts to get city approval for the expansion failed in 1975 and 1977. In the years since its opening, the vacant land surrounding the park had been built up with houses and apartments. These residents opposed the noise, traffic, and possible increase in crime that an expansion might bring. Unable to remain competitive, the park closed for good on September 28, 1980. The land intended for the expansion was instead used for condominiums. Much of the original parkland was bought by the City of San Jose for Edenvale Garden City Park. Every June, former park employees, visitors, and guests celebrate Frontier Village memories with a reunion and picnic in Edenvale Park. (Courtesy of the Sourisseau Academy.)

Four

CIVIC BUILDINGS

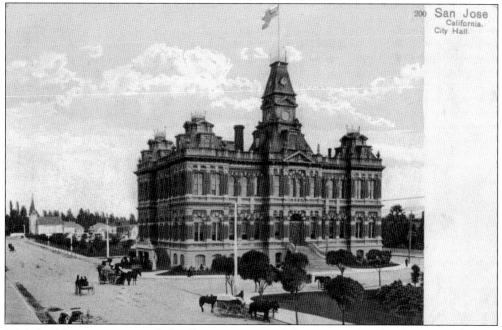

Civic buildings serve as symbols of government and the community. San Joseans took great pride in their public edifices, as shown by the number of postcards with their images. One of the most common was the grand old San Jose City Hall, which stood in the center of Plaza Park, now known as Plaza de Cesar Chavez. (Courtesy of the California Room.)

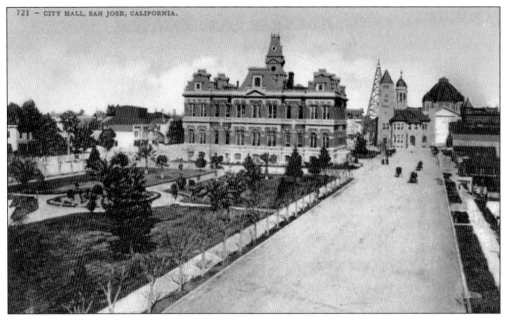

This view, looking north up Market Street from West San Carlos, shows city hall sitting in the middle of Plaza Park, where today the children's fountain bubbles. At the end of the street is the old San Jose Post Office, with glimpses of St. Joseph's Cathedral and the Electric Light Tower just beyond. With imagination, one can picture today's Fairmont Hotel opposite city hall on the right side of Market Street. (Courtesy of the Sourisseau Academy.)

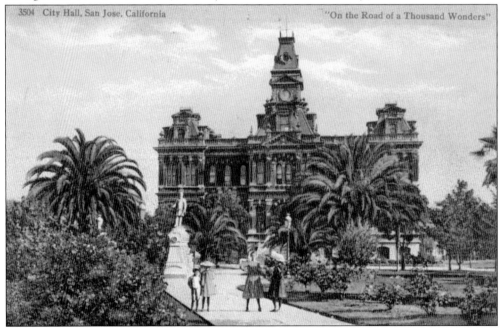

3504 City Hall, San Jose, California "On the Road of a Thousand Wonders"

Architect Theodore Lenzen gave San Jose City Hall its unique appearance by modeling it after a Victorian-era Bavarian town hall. It was completed in 1889 at a cost of $140,000. Besides the city council chambers and city offices, city hall housed the public library on the second floor and the city jail in the basement. (Courtesy of the California Room.)

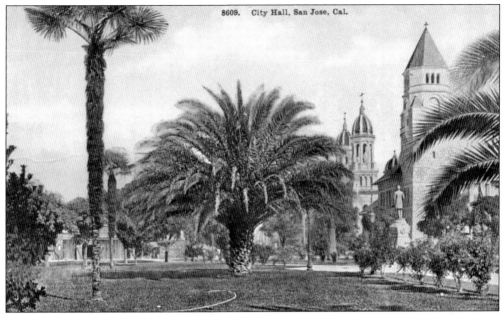

8609. City Hall, San Jose, Cal.

This view from the front steps of city hall looks past the palm trees at the northern end of Plaza Park. On the right are the post office and the twin spires of St. Joseph's Cathedral. Also on the right, a statue of San Francisco dentist Henry Cogswell stands atop a drinking fountain. Cogswell donated these fountains to cities in the hope that thirsty people would drink cool water rather than alcohol. (Courtesy of the Sourisseau Academy.)

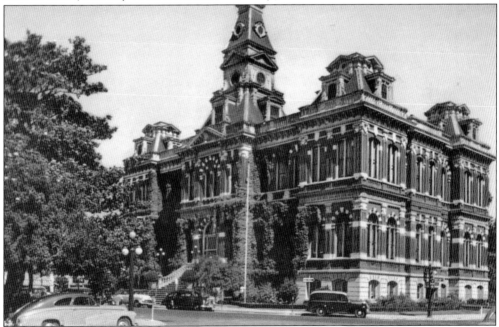

As the years passed, city hall became too cramped and in need of repairs. Some people loved its quirky style, while some local architects called it "a design reflecting a very bad period of German architecture." This was a time when the old and unusual was not thought worth preserving, so the old San Jose City Hall was demolished in the summer of 1958. (Courtesy of the California Room.)

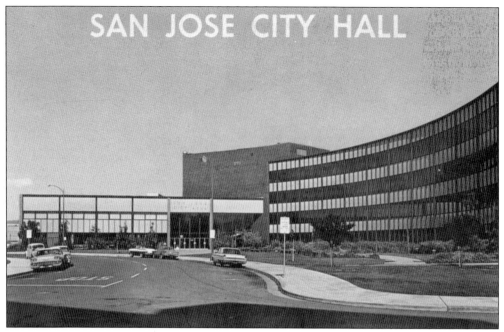

SAN JOSE CITY HALL

In 1958, a new San Jose City Hall opened at the corner of First and Mission Streets in the civic center complex north of downtown. The glass-fronted, four-story building curved into an arc 400 feet in length. It cost $26 million to construct and contained 106,000 square feet. (Courtesy of the California Room.)

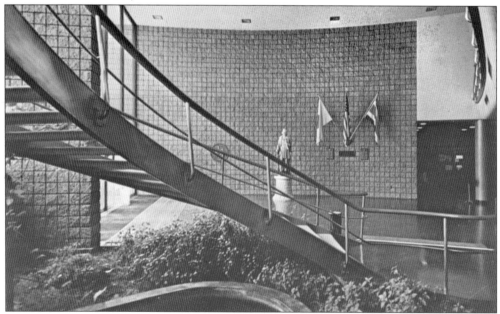

The lobby stairs leading to the second floor city council chambers floated over a fishpond. Against the back wall stood a 9-foot marble statue of Christopher Columbus, donated by the local Italian community. Ironically when city hall moved to larger quarters in 2005, it was located once more back downtown, on a site only five blocks from the location of the 1889 city hall. (Courtesy of the California Room.)

San Jose's need for more space for conventions and performances was met with the opening of the new 3,300-seat Civic Auditorium in 1936. The Spanish-style building was constructed at the corner of Market Street and San Carlos Avenue on land donated by T. S. Montgomery. When promised a federal grant of $113,000, voters approved by a 4-1 margin a $375,000 bond to fund the remainder of the cost. (Courtesy of the California Room.)

McCabe Hall was a 9,000-square-foot expansion added to the west side of the Civic Auditorium in 1963. It was named in honor of Jay McCabe, who managed the Civic Auditorium from its opening in 1936 until his retirement in 1954. In the early 1990s, McCabe Hall served as the temporary home of the Tech Museum of Innovation until a permanent home for the museum could be built. (Courtesy of the California Room.)

This view of the Civic Auditorium is from the center of Plaza de Cesar Chavez looking west across Market Street. The wing on the left is the Montgomery Theater, named in honor of land donor T. S. Montgomery. The 545-seat theater provides an intimate venue for cultural events and performances. (Courtesy of the California Room.)

This pleasant spot with fountains was built at the corner of Park Avenue and Market Street, when Parkside Hall was added to the Civic Auditorium complex. The tall structure in the rear is the back of the Civic Auditorium stage. This tranquil area was lost when the Tech Museum of Innovation was constructed on this site in 1998. (Courtesy of the California Room.)

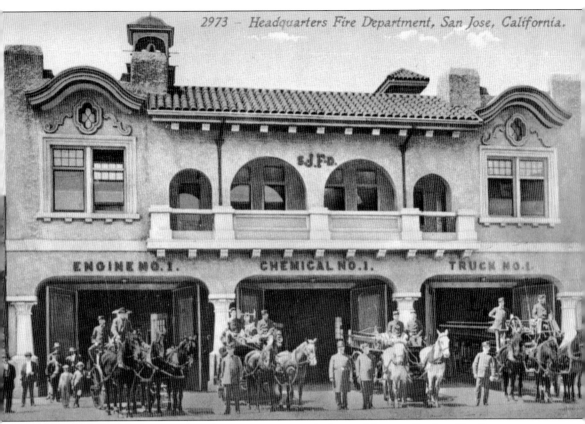

Fireman and their horse-drawn fire equipment pose in front of the new San Jose Fire Department headquarters at 35 North Market Street. The $25,000 building replaced the old headquarters, which was heavily damaged in the 1906 earthquake. The Mission Revival–style building was designed by Wolfe and McKenzie and was completed in 1908. Equipment was stored on the first floor, while the second floor housed a 24-man dormitory, a reading room, and a billiard room. It served as the San Jose Fire Department headquarters until 1951, when a new headquarters was opened at Market and St. James Streets. The old headquarters was demolished in 1951. If one stands here now in front of the Sonoma Chicken Coop, it is possible to imagine the ghostly echoes of sirens and fire alarms. (Courtesy of the California Room.)

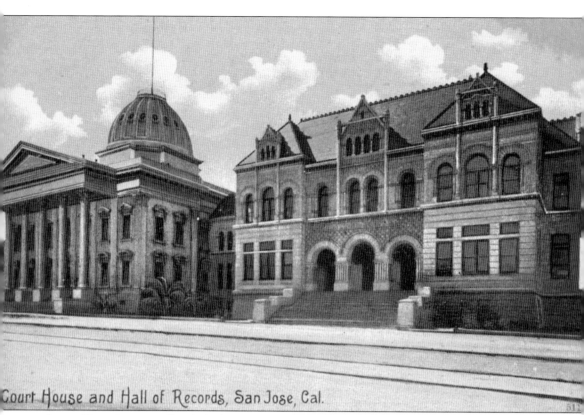

Court House and Hall of Records, San Jose, Cal.

Santa Clara County officials had another goal in mind when they built an imposing new courthouse (left) in 1868. They hoped the state legislature would see a potential statehouse in its marble walls, stately columns, and impressive dome and would return the state capital to the city it had left in 1852. But the state legislature stayed in Sacramento, and the courthouse fulfilled its original function by dispensing justice in one of three courtrooms under its large dome. In 1931, fire gutted the building and destroyed the dome. The courthouse was reconstructed the following year with a third floor to accommodate more courtrooms, but the dome was never rebuilt. The brick-and-granite Hall of Records (right) was constructed in the Romanesque Revival style in 1892. It stored official county records such as deeds and birth and death records. It was demolished in December 1962, and the space was used as the courtyard entrance to the new Santa Clara County Superior Court Building. (Courtesy of the California Room.)

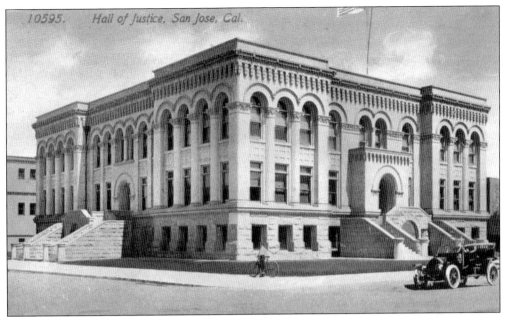

The Hall of Justice was a sandstone building at the southeast corner of Market and St. James Streets. The new structure was awaiting dedication when it was badly damaged in the 1906 earthquake. It was rebuilt and opened in 1908. For many years, the Hall of Justice housed the municipal court and other county offices. It was demolished in 1962 and was replaced with the Santa Clara County Superior Court Building. (Courtesy of the California Room.)

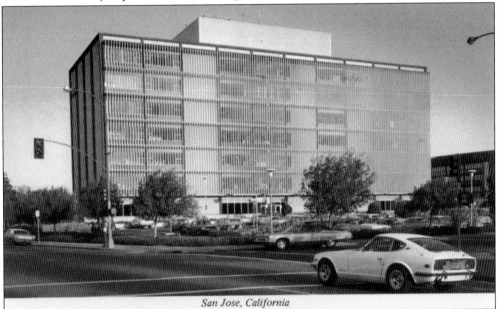

In 1961, Santa Clara County offices scattered throughout San Jose moved into this new $3 million county office building in the new civic center complex, located at First and Hedding Streets. Its distinctive striped exterior is caused by 1,200 vertical aluminum louvers, which could be adjusted to regulate the amount of light and heat entering the structure. It is now the west wing of the County Government Center. (Courtesy of the Sourisseau Academy.)

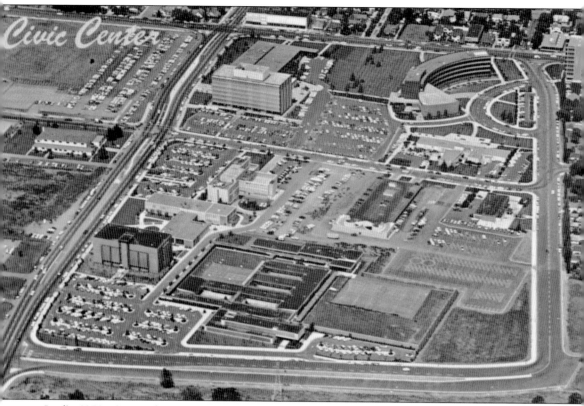

In the 1950s, Santa Clara County encouraged the development of a civic center where county, city, state, and federal offices would be centrally located. Half a square mile of land north of downtown San Jose was set aside for this purpose. In this view from the 1960s, the civic center was bordered by West Mission Street on the right, West Hedding Street on the left, North First Street at the top, and the future Guadalupe Parkway at the bottom. The curving San Jose City Hall is at the upper right, and the Santa Clara County Office Building is at the upper left. In the lower left were the Santa Clara County Superior Court Building and the Santa Clara County Jail. As the county grew so did the number of buildings in the civic center, but with no unifying style, since the government agencies involved could never agree on a master plan. In 2005, San Jose moved its city hall downtown, leaving the old building in the civic center vacant. (Courtesy of the Sourisseau Academy.)

When Congressman T. J. Clunie was elected in 1888, he promised the voters a new San Jose Post Office. He kept his word, and in 1890, Congress appropriated $200,000 for the project. The fortress–like structure was built with thick walls of sandstone blocks quarried by Italian stonemasons from the Almaden quarry in south San Jose. The new post office was opened on February 1, 1895. (Courtesy of the California Room.)

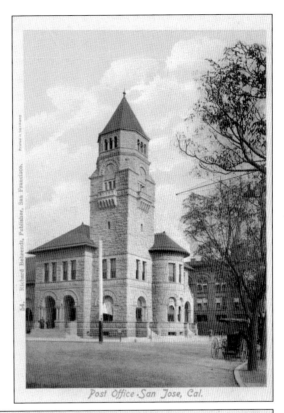

Post Office - San Jose, Cal.

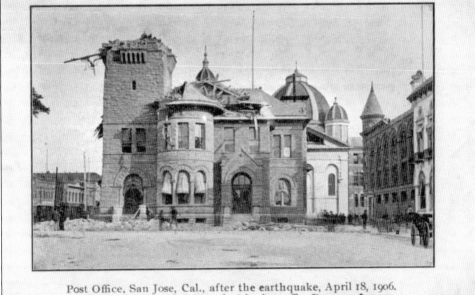

Post Office, San Jose, Cal., after the earthquake, April 18, 1906.
Original height 120 feet. 45 feet broken off. Damage $40,000.

Post office architect Willoughby Edbrooke's reluctance to add a steeple to the post office tower proved prophetic when the steeple collapsed and fell into the street during the 1906 earthquake. Most of the damage to the structure was caused by debris from the fallen steeple. The rest of the structure was sound and was quickly rebuilt, minus the steeple. (Courtesy of the California Room.)

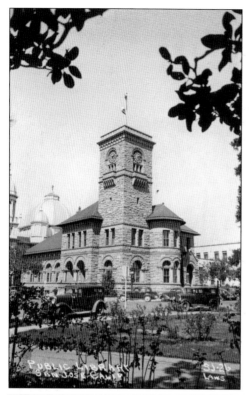

A new clock was installed in the truncated tower to replace the one destroyed in the earthquake. Designed by Danish immigrant Nels Johnson, it was a Century Clock guaranteed to last 100 years. The clock has indeed lived up to its name by running continuously since 1908. The old post office housed the San Jose Public Library from 1937 to 1970 and is now part of the San Jose Museum of Modern Art. (Courtesy of the California Room.)

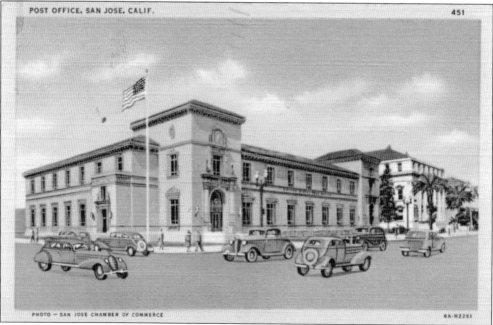

In 1934, a new San Jose Main Post Office opened on the site of the St. James Hotel. Designed in the Spanish Colonial Revival style by Ralph Wycoff, the structure featured marble floors and wooden ceilings. Although replaced as the main post office in 1966 by a new building on Meridian Avenue, it still serves as a branch post office today. (Courtesy of the California Room.)

Five

ALUM ROCK PARK

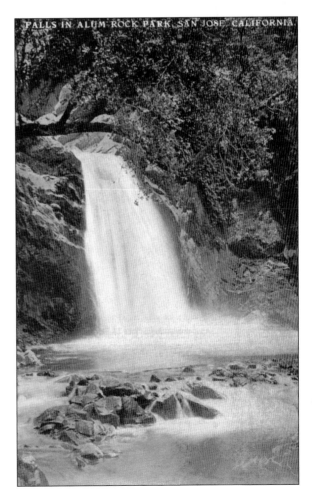

FALLS IN ALUM ROCK PARK, SAN JOSE, CALIFORNIA.

Since the late 19th century, Alum Rock Park has been a retreat for city residents wishing to escape into nature. Set in the western foothills of the Mount Hamilton Range, the park was established as a 400-acre city reservation by the California legislature in 1872. Among the attractions are waterfalls such as this one on Penitencia Creek. (Courtesy of the California Room.)

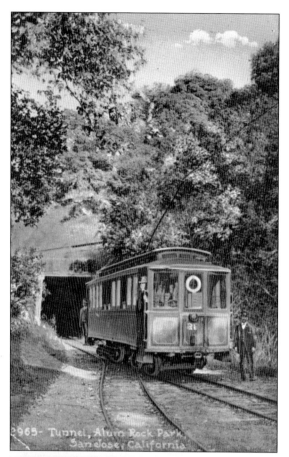

2965- Tunnel, Alum Rock Park, San Jose, California.

One of the popular ways of reaching the park in the early 20th century was on the electric narrow-gauge railway. Cars of the San Jose and Santa Clara Railway Company would transport visitors to the park for a round-trip fare of 50¢. Here the conductor stands next to car No. 26 outside one of the two narrow tunnels into the park. On April 15, 1909, fifteen-year-old Richard Brown stuck his head out of a railway car window just as it entered one of the tunnels. His head struck a protruding timber, jerking him out of the window and crushing him between the car and the tunnel wall. After this tragedy conductors would order that all windows be closed before entering any of the tunnels. (Both, courtesy of the Sourisseau Academy.)

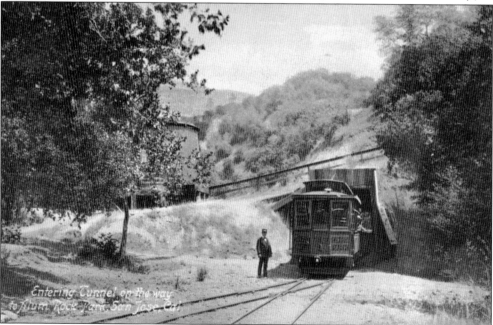

Entering Tunnel on the way to Alum Rock Park, San Jose, Cal.

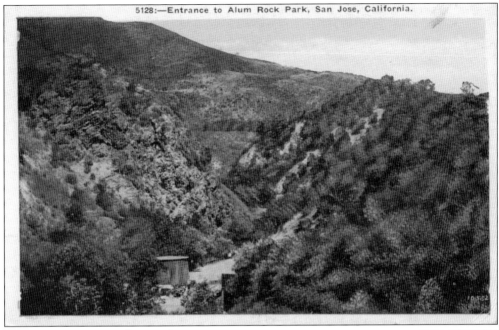

The park occupies the floor and steep slopes of Alum Rock Canyon. The park got its name from a large rock in the lower part of the park that was thought to contain high concentrations of alum. Residents would often invite first-time visitors to taste the alum powder and laugh as they reacted to the awful taste. Later tests showed the powder was not alum but gypsum. (Courtesy of the Sourisseau Academy.)

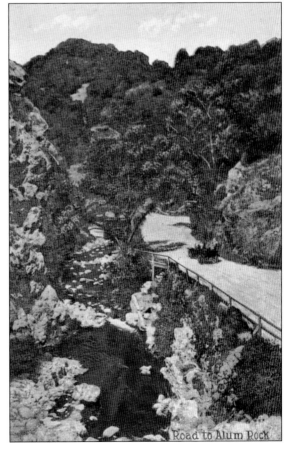

Road to Alum Rock

With the rise in automobile ownership, more people chose to drive into the park. The number of people riding the railway into the park declined, and the line was shut down in 1931. (Courtesy of the California Room.)

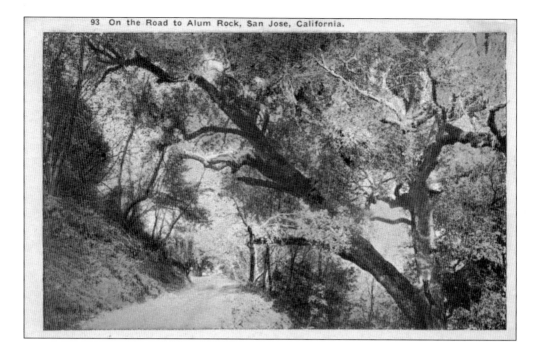

93 On the Road to Alum Rock, San Jose, California.

The drive into the park was scenic, as the road wove among the trees and over stone bridges crossing Penitencia Creek. (Above, courtesy of the California Room; below, courtesy of the Sourisseau Academy.)

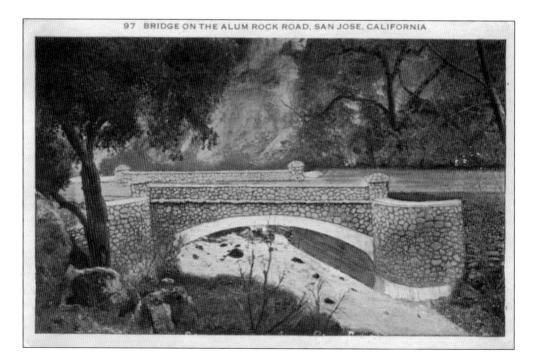

97 BRIDGE ON THE ALUM ROCK ROAD, SAN JOSE, CALIFORNIA

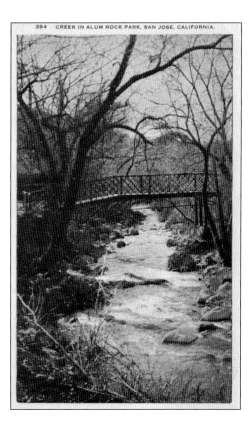

Penitencia Creek runs through the floor of Alum Rock Canyon. A tributary of Coyote Creek, it was originally called *Arroyo Aguaje* by the Spanish, meaning "a watering place for cattle." There are differing accounts of why it was renamed Penitencia Creek. One story is that there was an adobe by the creek where priests used to hear confessions and give out penance. Another relates that the priests from Mission Santa Clara used to come to a spot by the creek to meditate. There is a pleasant hiking trail following the creek from the park entrance to the waterfalls at the upper end of the park. (Both, courtesy of the California Room.)

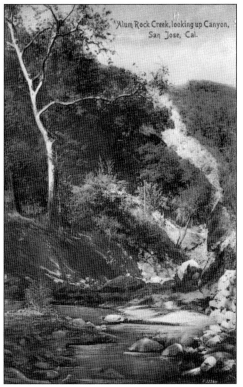

Alum Rock Creek, looking up Canyon, San Jose, Cal.

81

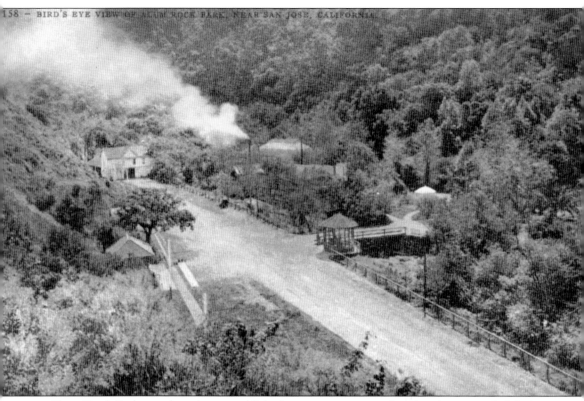

Alum Rock Park may have been established as a nature reservation, but it was not left in its natural state. Early in its history, efforts were made to develop the park and mineral springs into a spa resort that would attract visitors from all over the San Francisco Bay area. The development took place mainly in a 25-acre flat section in the widest part of the canyon. Here was the railway station, as well as later parking for automobiles. In the 1870s, a small hotel was built, but it burned to the ground in 1890. In the early 1900s, after the railway made the park more accessible, a grand new hotel was proposed for the park but was never constructed. But other attractions were developed, which continued to bring more visitors into the park. (Courtesy of the Sourisseau Academy.)

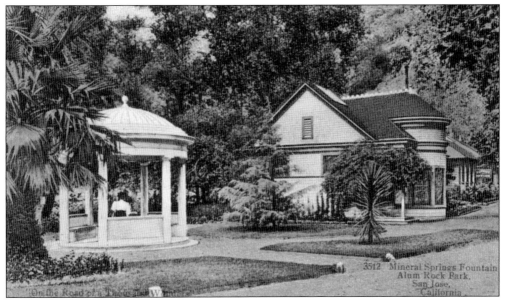

One of the chief attractions was the mineral springs scattered throughout the park. In the late 19th and early 20th centuries, doctors recommended natural mineral water for the treatment of a number of ailments. The underground springs absorbed minerals from the rocks around them, giving their water a distinctive taste and smell. Among the elements identified in tests of the Alum Rock mineral springs were black sulfur, soda, magnesium, iron, and white sulfur. The springs were tapped and carried by pipes to points where visitors could drink the water or bathe in it. There was a bathhouse for men and a separate bathhouse for ladies (above right). There were also drinking fountains available (above left and below) for those who preferred to drink the water rather than bathe in it. (Above, courtesy of the California Room; below, courtesy of the Sourisseau Academy.)

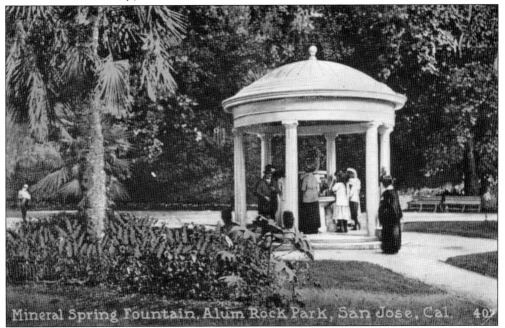

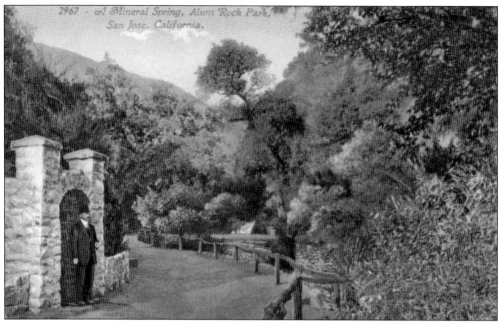

At one time, 27 mineral springs had been identified in the park. An unidentified gentleman stands in front of one of the springs, which had been enclosed in a stone grotto. One writer described these grottoes as stone structures resembling tombs. A tomb might have been an appropriate shelter for one of the park's springs, which supposedly contained traces of arsenic. That dangerous spring was capped to protect visitors. (Courtesy of the California Room.)

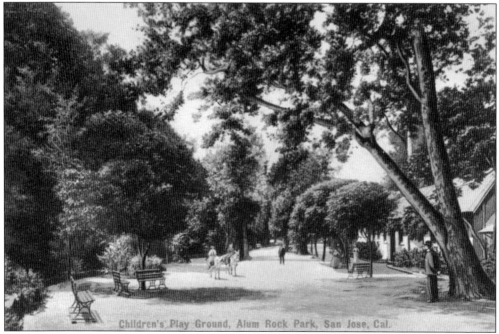

Smelly water and mineral baths did not appeal to all visitors, especially children. There were other amusements in the park, such as a children's playground and a livery stable where ponies and horses could be rented. (Courtesy of the Sourisseau Academy.)

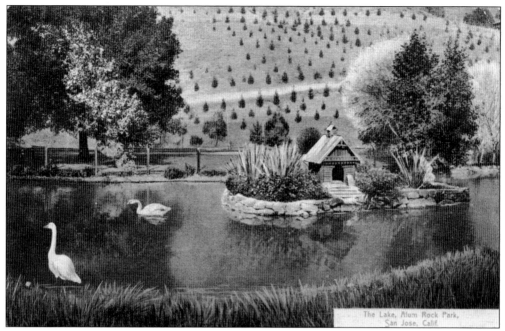

A small lake was home to a pair of swans. (Courtesy of the California Room.)

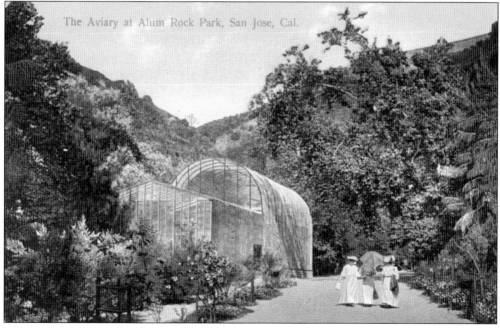

The aviary held both local and exotic birds, ranging from peacocks to canaries. At one time a solitary brown bear was on display in a nearby pen. After the hotel burned down, the space it had occupied was fenced in and populated with several species of deer. The deer were eventually moved to the zoo in Kelley Park. (Courtesy of the California Room.)

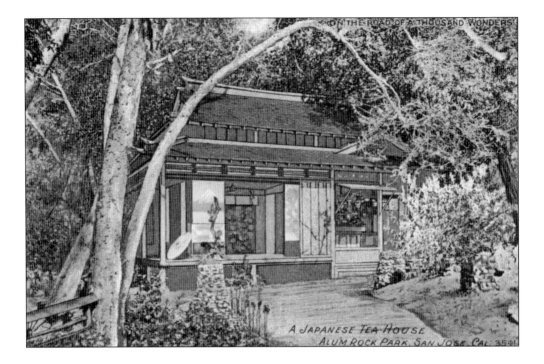

The Japanese Tea House and gardens that stood on the banks of Penitencia Creek were popular with visitors. The teahouse was later torn down and replaced with a café. (Above, courtesy of the California Room; below, courtesy of the Sourisseau Academy.)

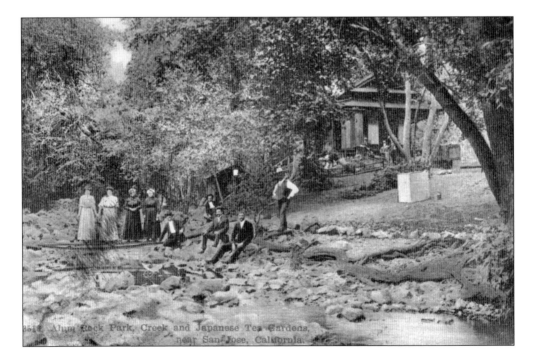

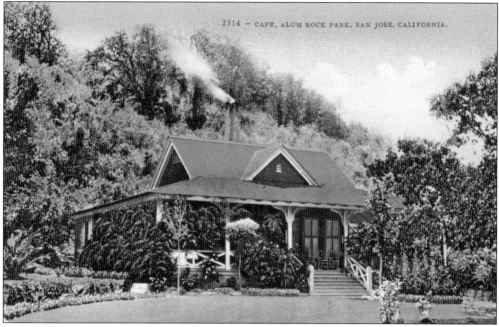

Visitors to the park in the early 20th century could find refreshments at this small café. (Courtesy of the California Room.)

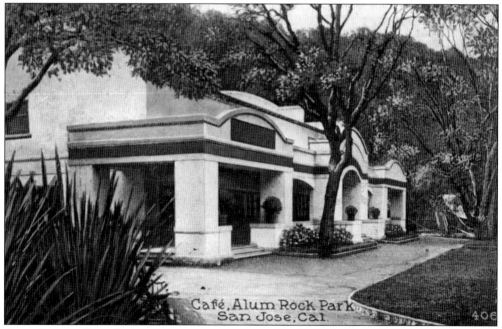

A new larger café was built in 1913 as part of a park enhancement project. The café was constructed on the site of the Japanese Tea House at a cost of $4,500. It was designed by local architect Frank Wolfe and featured oversize columns and shaded porches. The café was demolished in the 1970s. (Courtesy of the California Room.)

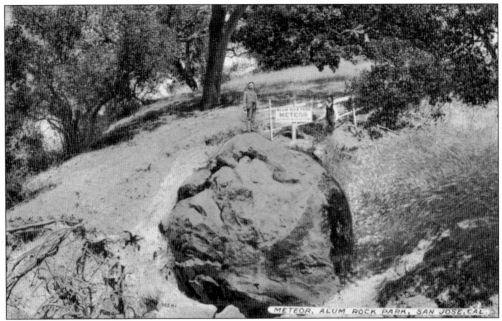

Many visitors to the park would have their picture taken next to the Alum Rock Meteor. The meteor stood next to Penitencia Creek in the lower end of the park. Park promotional brochures gave its estimated weight as 2,000 pounds and described it as being one of the largest meteors in the world. Some scientists disagreed, arguing that it was not a meteor at all but merely an outcropping of rock. Meteor or not, tests showed that it contained a high manganese content. America had entered World War I, and the manganese needed to manufacture hardened steel, for armor plating was in short supply. The San Jose City Council was urged to sell the rock for the war effort. Some people objected, declaring "Don't destroy this. Somebody else may want to see it." But patriotism prevailed, and the rock was broken up and hauled to a steel mill. Ironically, the war ended before the manganese extracted by destroying the rock could be used. (Above, courtesy of the California Room; below, courtesy of the Sourisseau Academy.)

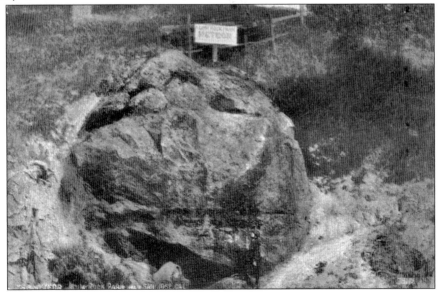

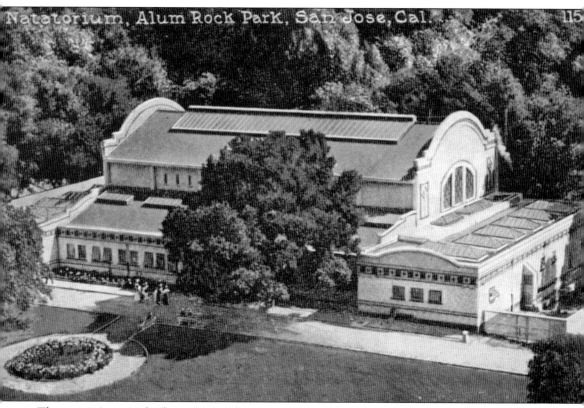

The natatorium was built in 1913, at the same time as the new café. The glass-roofed structure enclosed an indoor heated swimming pool, measuring 95 feet long and 45 feet wide. There was a springboard for divers, as well as fixed diving platforms at 8, 10, and 20 feet for the more adventurous. A two-story aquatic slide provided a fun way to enter the pool. Spectators could watch the action from an elevated gallery around the interior of the building. In addition to the pool, there were hot and cold sulfur baths. There were 31 baths for men at one end of the building and 10 for women at the other end. The pool was remodeled in 1940 as a WPA project. But the character of the park was changing. The natatorium was closed in 1971 and was demolished a few years later. (Courtesy of the California Room.)

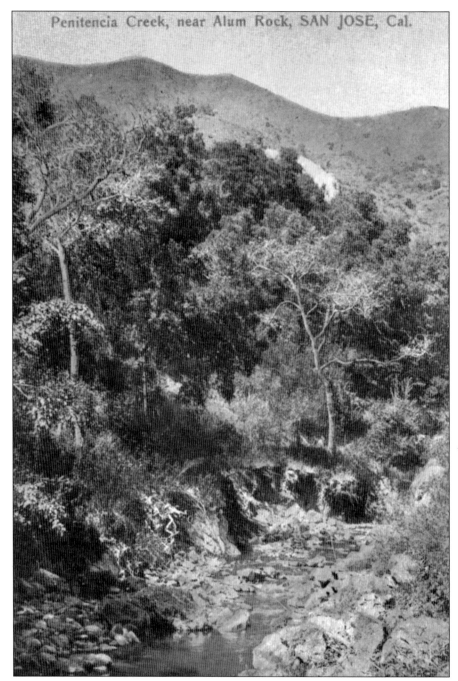

Penitencia Creek, near Alum Rock, SAN JOSE, Cal.

The park had reached its peak of popularity in the 1920s. Attendance declined during the Depression and World War II. Park usage increased after the war, but years of overuse and overcrowding had left its impact. It was decided to return the park to a more natural state. Gone were the aviary, deer pens, restaurant, dance pavilion, and other concessions. Today the park draws visitors interested in hiking, picnicking, bicycling, horseback riding, and other activities that do less harm to the natural environment. The park has returned to its original purpose as a rustic oasis for urban dwellers. (Courtesy of the Sourisseau Academy.)

Six

THE GARDEN CITY

A Palm Garden in San Jose, Cal.

"The Garden City" was a nickname well suited to San Jose. It was a city set in the middle of a fertile valley surrounded by orchards and fields. Trees and gardens thrived in moderate temperatures and rainfall. Comfortable houses were set on tree-lined streets. Signs of nature were never far away. The Garden City was a pleasant place to live and work. (Courtesy of the Sourisseau Academy.)

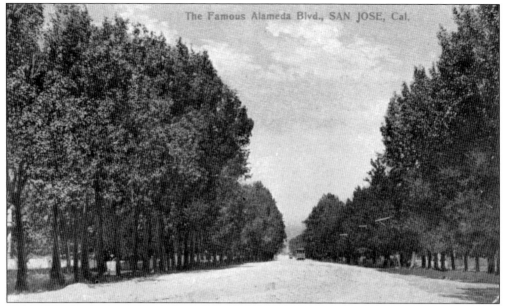

The Famous Alameda Blvd., SAN JOSE, Cal.

The Alameda, which in Spanish means "shady walk," was built by the mission padres to connect the pueblo of San Jose with Mission Santa Clara. The padres wished to encourage people to make the long walk from San Jose in the summer heat to attend Sunday mass at the mission. So the padres planted the sides and middle of the wide road with rows of willow trees to provide shade. The Alameda eventually became the main thoroughfare between San Jose and the city of Santa Clara. In the late 19th and early 20th centuries, The Alameda became an upscale boulevard lined with mansions and estates. While the streetcars and most of the trees have disappeared, and the mansions have been converted into professional offices, today The Alameda remains an important urban artery. (Above, courtesy of the Sourisseau Academy; below, courtesy of the California Room.)

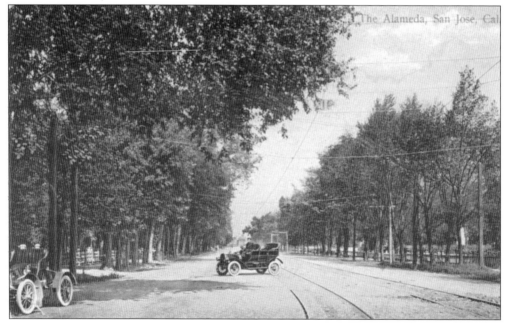

A RESIDENCE STREET, SAN JOSE, CALIFORNIA.

The white house on the right is located at 1163 Martin Avenue, just off The Alameda in the Hanchett Park neighborhood. Built in 1913 for wholesale grocer Peter Col, it was designed by local architect Frank Delos Wolfe in the prairie-school style. The four-bedroom, one-bath house is considered to be one of Wolfe's most important and influential designs. (Courtesy of the Sourisseau Academy.)

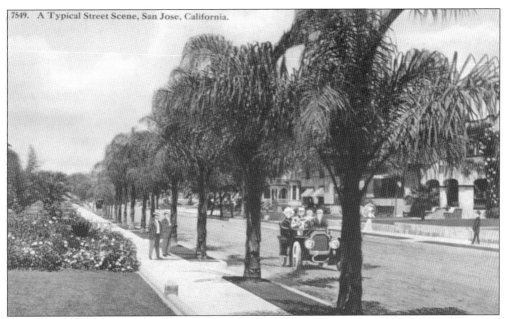

7549. A Typical Street Scene, San Jose, California.

Residents stroll and drive through the palm-lined streets of one of San Jose's neighborhoods. (Courtesy of the Sourisseau Academy.)

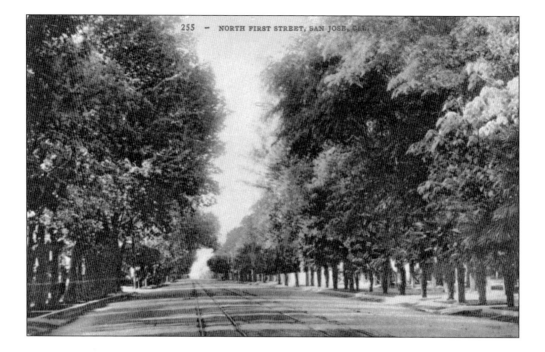

These views of First Street (above) and Third Street (below) show the quiet, tree-lined streets enjoyed by residents of San Jose. (Both, courtesy of the California Room.)

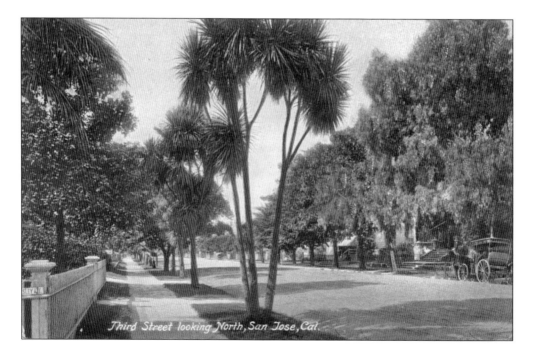

Third Street looking North, San Jose, Cal.

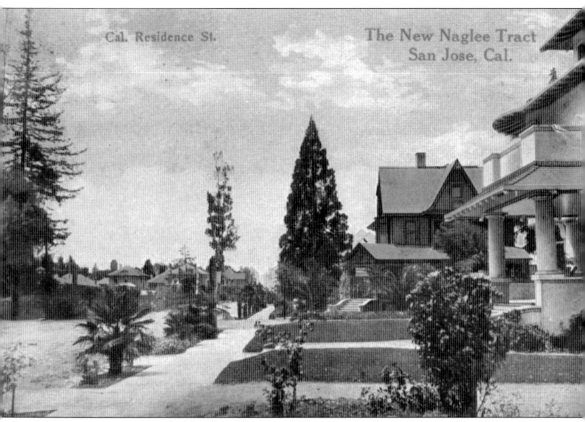

Cal. Residence St.

The New Naglee Tract
San Jose, Cal.

The Naglee Park Tract was San Jose's first planned subdivision. It was developed beginning in 1902 on the 140-acre estate of the late general Henry Morris Naglee. The developer cleared and graded the land, paved the streets, and added sewers. Only the lots were sold within the subdivision. Each house was then custom-built by the new owner, but required to be worth at least $2,000. Stables and barns had to be set at the back of the lot rather than next to the street. The tract proved popular with businessmen and professionals who worked in nearby downtown San Jose. The large house on the rear right with the chimney is the Naglee Mansion, which was later converted into an apartment house. The house on the far right with the front porch columns was the residence of George and Lucy Herbert. It was designed by Wolfe and McKenzie and was built in 1905 on the largest lot in Naglee Park. (Courtesy of the Sourisseau Academy.)

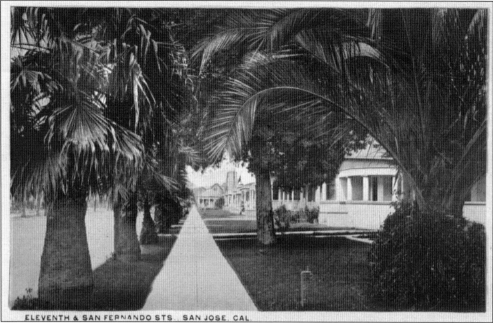

ELEVENTH & SAN FERNANDO STS., SAN JOSE, CAL.

This is the view looking north up Eleventh Street from the corner of San Fernando in Naglee Park. Many of the houses on this stretch of Eleventh Street have been replaced by apartment buildings. (Courtesy of the Sourisseau Academy.)

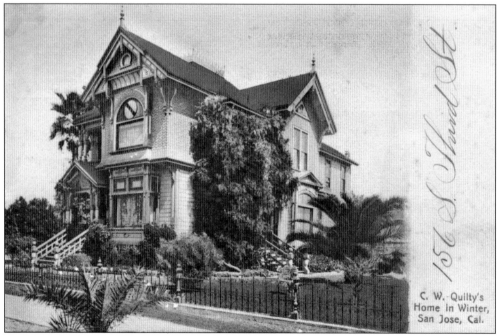

C. W. Quilty's Home in Winter, San Jose, Cal.

156 S. Third St.

Charles W. Quilty was a San Jose attorney and president of the San Jose Light and Power Company. He owned this house at 156 South Third Street, just north of the intersection of San Antonio Street with South Third Street. This space is now covered by the Paseo Plaza Condominium complex. (Courtesy of the California Room.)

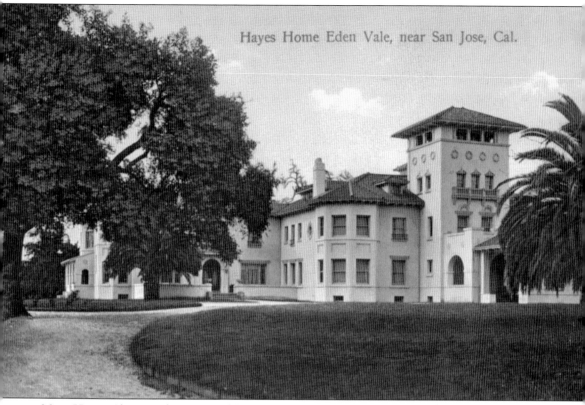

Hayes Home Eden Vale, near San Jose, Cal.

Mary Hayes-Chynoweth was a wealthy widow who, in 1887, acquired a 240-acre tract of land in the Edenvale area of San Jose. In 1890, she built a four-story wooden mansion on the estate. When the house burned to the ground in 1899, she immediately began planning the construction of an even larger house. The 64-room Hayes Mansion was constructed in the shape of a Maltese cross, with rooms for Hayes-Chynoweth in the center and wings on either side for her two sons and their families. Mindful of the fate of the first house, the second was built with fireproof walls of stucco-coated brick 2 feet thick. The luxurious interior featured walls paneled in white oak, maple, mahogany, and walnut. Hayes-Chynoweth died shortly after the mansion was completed in 1905. Her two sons, Everis and Orley Hayes, continued to live there until their deaths in the 1940s. The building was vacant and deteriorating when the City of San Jose purchased it in 1985 for $1.5 million. After renovations, the mansion reopened as a conference center. (Courtesy of the Sourisseau Academy.)

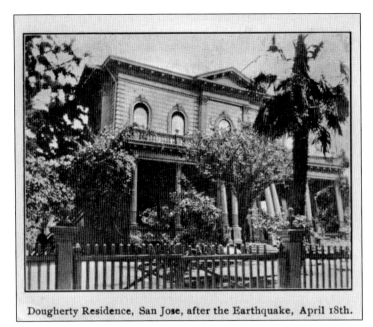

Dougherty Residence, San Jose, after the Earthquake, April 18th.

The Dougherty house was one of many in the city damaged by the 1906 earthquake. It was located at 460 North Fifth Street. William Dougherty was the founder of Dougherty Lumber Company, one of the largest in the state. When he died in 1894, his wife assumed management of the company. The house was repaired, and Mrs. Ann Dougherty continued to live there until 1915. An apartment building now occupies the space. (Courtesy of the California Room.)

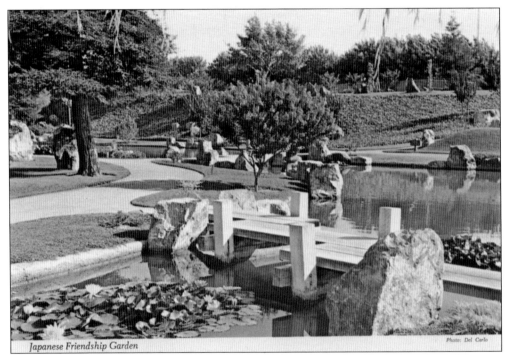

Japanese Friendship Garden

Photo: Del Carlo

Evil spirits are not allowed to disturb the tranquility of the Japanese Friendship Garden in Kelley Park. The traditional Japanese garden was built in 1965 as a symbol of friendship between San Jose and its Japanese sister city of Okayama. The bridge over the lagoon was designed in a zigzag pattern so that evil spirits attempting to cross would fall into the water instead. (Courtesy of the California Room.)

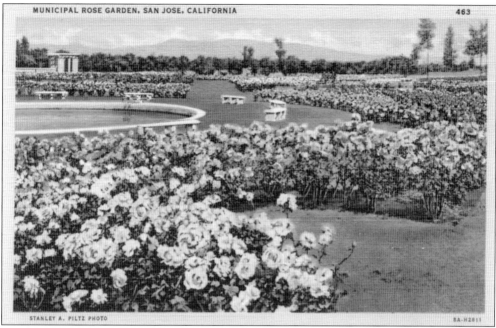

STANLEY A. PILTZ PHOTO 8A-H2811

The establishment of the beautiful municipal rose garden was suggested by the Santa Clara County Rose Society. The city council agreed and set aside part of an 11-acre city park at Dana and Naglee Avenues for the garden. Plans for the garden were prepared at no cost by noted horticulturist John McLaren. The garden was dedicated on May 15, 1937. The 5.5-acre garden contains more than 3,500 rose bushes, representing 230 rose varieties. A group of dedicated volunteers (Friends of the San Jose Rose Garden) helped rejuvenate the garden after years of neglect caused by city budget cuts. In 2009, the San Jose Municipal Rose Garden was designated an All-America Rose Selection Test Garden, one of 23 in the United Sates, and the only one in Northern California. (Above, courtesy of the California Room; below, courtesy of the Sourisseau Academy.)

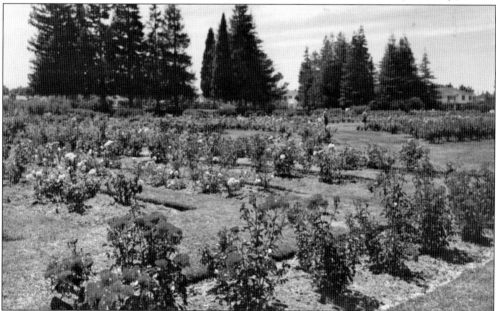

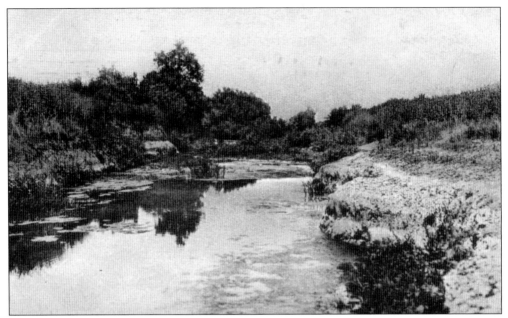

The Guadalupe River (above) presents a peaceful scene as it winds its way through San Jose on its journey to San Francisco Bay. In the 1850s, the river provided water for crops and drinking water for the citizens of San Jose. Mills were built on its banks to grind grain. But its tranquil waters can be deceiving. The Guadalupe is a shallow river and can easily flood with too much runoff. San Jose's original Spanish settlement had to be moved away from the river, when floods kept destroying crops. Over the years, downtown San Jose streets and houses have been flooded many times. After $250 million in flood control projects during a 30-year period, the Guadalupe River may finally have been tamed. Coyote Creek (below) also flows through San Jose. It is seen here passing beneath an unidentified bridge. (Both, courtesy of the Sourisseau Academy.)

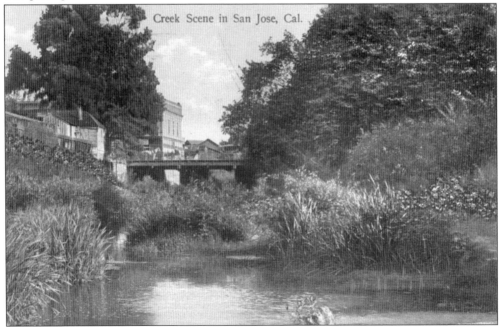

Creek Scene in San Jose, Cal.

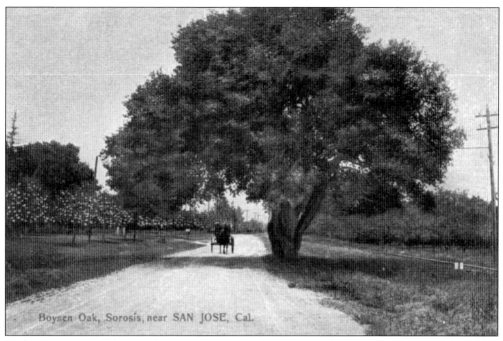

Boysen Oak, Sorosis, near SAN JOSE, Cal.

Early visitors to California often commented on the number of oaks found growing here. Their acorns were a staple food of the Ohlone Indians who were living in the area. When Fr. Juan Crespi traveled through eastern Santa Clara County in 1772, he gave the name "Llano de los Robles" (Spanish for "plain of oaks") to this part of the county. The Boysen Oak (above) stood on Saratoga Road on the property of the Sorosis Orchard Company. It was much admired for its size and symmetry, and it was the subject of paintings and photographs. It was removed when Saratoga Avenue was widened. The location of the large oak (below) is not known. It may still be standing, but more likely it has fallen due to disease, old age, or the encroachment of civilization. It is a reminder of the giants that used to dot the valley floor. (Above, courtesy of the California Room; below, courtesy of the Sourisseau Academy.)

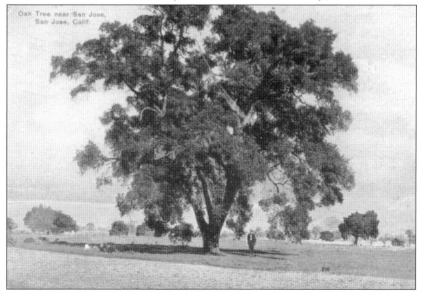

Oak Tree near San Jose, San Jose, Calif.

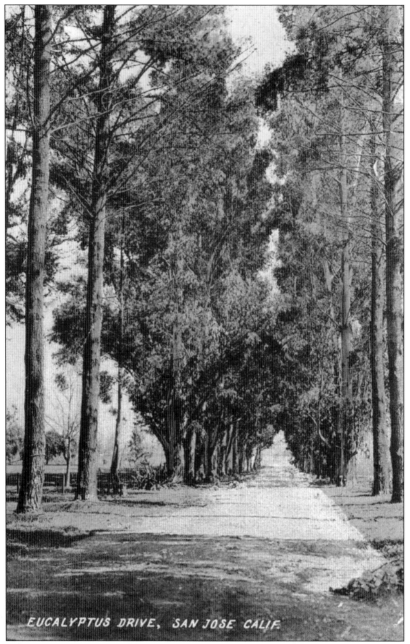

EUCALYPTUS DRIVE, SAN JOSE CALIF.

As native oaks disappeared, the nonnative eucalyptus became more common. Originally from Australia, eucalyptus trees were planted in large numbers in California in the late 19th and early 20th centuries. It was thought the fast-growing tree would be a bountiful source of firewood and lumber. But the hardness of the wood made it difficult to cut for firewood, and the crooked grain made it useless for building lumber. The shallow root system made it liable to fall over during a windstorm, and the oil-rich wood burned fiercely if the tree caught on fire. But the eucalyptus was still valued as a windbreak and shade tree. Eucalyptus groves can still be found in the county, and old-timers may remember stands of eucalyptus along Alum Rock and Lincoln Avenues. (Courtesy of the California Room.)

Seven

COMMUNITY

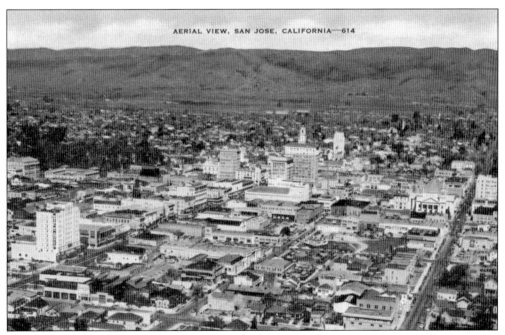

This aerial view shows San Jose in the mid-1940s. The population had reached 80,000, but the expanding city was still surrounded by orchards and fields. Structures like the Bank of Italy tower dominate downtown. But a city is more than buildings. A city is the people, organizations, and institutions that bring it together as a community. (Courtesy of the California Room.)

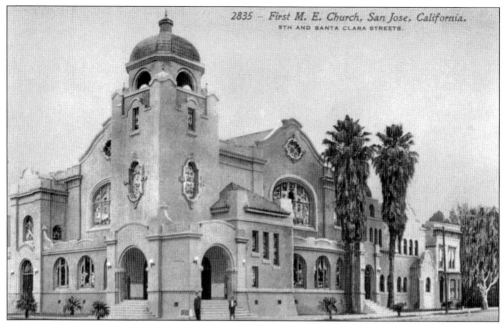

The First Methodist Episcopal Church was built on the northeast corner of Fifth and Santa Clara Streets to replace a church on North Second Street destroyed in the 1906 earthquake. The Spanish Revival–style church was dedicated on March 19, 1911. It had beautiful stained glass windows and an exceptional pipe organ. The church was destroyed by fire in 1991, but the congregation is planning to rebuild in the future. (Courtesy of the California Room.)

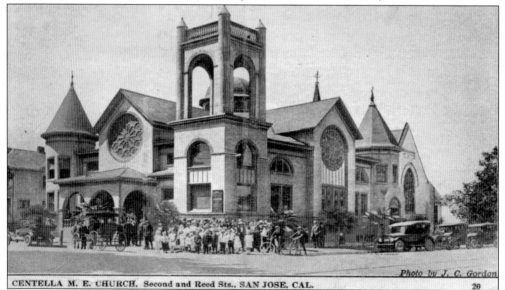

Centella Methodist Episcopal Church was built at Reed and Second Streets to replace an older and smaller Methodist Episcopal church on the same site. The original church had been funded by Mrs. L. C. McColl, who requested the church be named Centella in honor of her deceased eight-year-old daughter. When the neighborhood changed from residential to commercial, the church was closed, and the congregation merged with St. Paul's Episcopal Church downtown. (Courtesy of the California Room.)

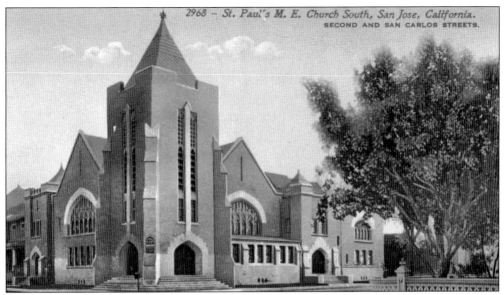

St. Paul's Methodist Episcopal Church belonged to one of the oldest congregations in San Jose. This brick building on Second and San Carlos Streets was dedicated in 1909, replacing previous churches destroyed by fire and earthquake. After the merger with Centella, a new church was constructed at Tenth and San Salvador Streets. The older church was demolished to make way for additional parking for Hale's Department Store. (Courtesy of the California Room.)

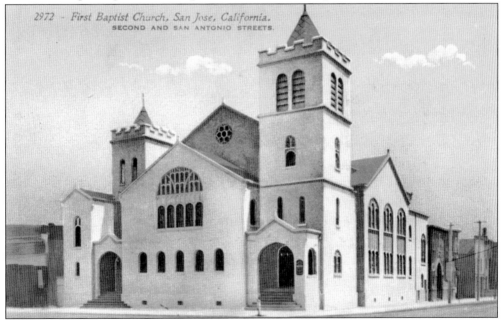

First Baptist Church of San Jose is the second-oldest Baptist congregation in California. This church opened in 1883 at the northeast corner of Second and San Antonio Streets. It survived the 1906 earthquake with little damage. In 1970, the congregation moved to a new church on a hilltop overlooking Curtner Avenue and Almaden Expressway. The old church was scheduled to be torn down but was destroyed by fire before demolition could begin. (Courtesy of the California Room.)

The First Church of Christ Scientist sits at 43 East St. James Street across from St. James Park. This neoclassical jewel, with its four Doric columns, was designed by noted San Francisco architect Willis Polk. The church is laid out in the shape of a Greek cross. The building has been vacant since 1975, when the congregation moved to larger quarters. The future of the deteriorating structure is uncertain. (Courtesy of the California Room.)

When both churches were destroyed in the 1906 earthquake, the Christian Church and the Central Christian Church decided to merge and build a new church. The $30,000 First Christian Church was constructed along classical lines at 80 South First Street. It was destroyed by fire in 1937. A new church was constructed on the same spot, where it still stands today, just a few steps from San Jose City Hall. (Courtesy of the California Room.)

Established in 1849, First Presbyterian Church is the oldest continuing Protestant congregation in San Jose. This church on North Third Street was completed in 1908. The building was condemned as a fire hazard in 1968. Stained glass windows from the old church were installed in the new church at 49 North Fourth Street, before the old church was demolished. The Town Park Towers senior citizens residence now occupies this space. (Courtesy of the California Room.)

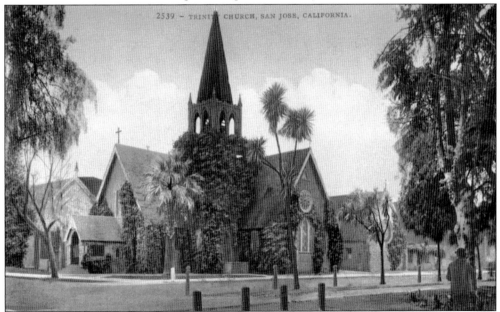

Trinity Church was built in 1863 at the northwest corner of Second and St. John Streets. One observer noted that the first-growth redwood used in construction was "fitted together with the ship builder's art." It survived the 1906 earthquake so well that it served as a refuge for San Franciscans displaced by the earthquake. It still stands here as the last surviving example of Carpenter Gothic architecture in San Jose. (Courtesy of the California Room.)

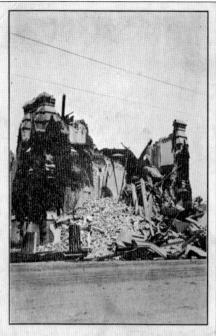

The ruin of St. Patrick's Church clearly demonstrates the destructive impact of the 1906 earthquake on brick structures. The church had been built in 1881 at the northwest corner of Ninth and Santa Clara Streets and could seat up to 600 worshippers. St. Patrick's is the second-oldest Catholic parish in San Jose. (Courtesy of the California Room.)

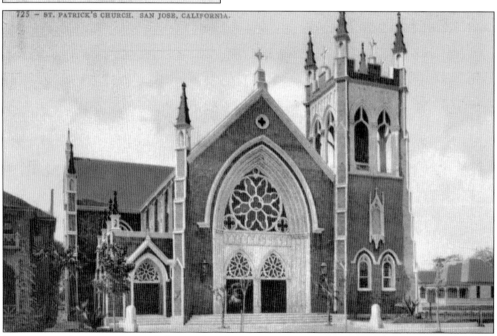

Just one year later, a new wood-frame church with shingle siding was dedicated on the same site. The damaged bell from the old brick church was recast and hung in the new structure. Termites and dry rot forced the demolition of the building in 1968. The site was used as a parking lot for St. Patrick's Elementary School, and a new church was constructed at Eighth and Santa Clara Streets. (Courtesy of the California Room.)

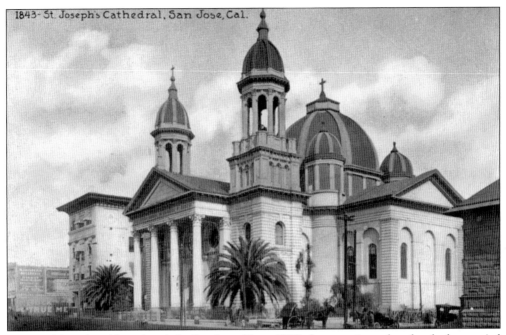

St. Joseph's is the oldest church in San Jose. Since 1803, four previous churches had occupied this spot at Market and San Fernando Streets before this structure was dedicated in 1877. Built in the shape of a classical Greek cross, the church still stands at this corner today. In 1990, St. Joseph's became the Cathedral for the Diocese of San Jose, and in 1993, it was honored with the title of "Basilica." (Courtesy of the California Room.)

The Church of the Holy Family was built at the northwest corner of San Fernando and River Streets with donations from the local Italian community. The Italian Renaissance–style church was inspired by St. Peter's Basilica in Rome. The building was demolished in 1969 to make way for the Guadalupe Parkway, and the congregation moved to a new church on Pearl Avenue. (Courtesy of the California Room.)

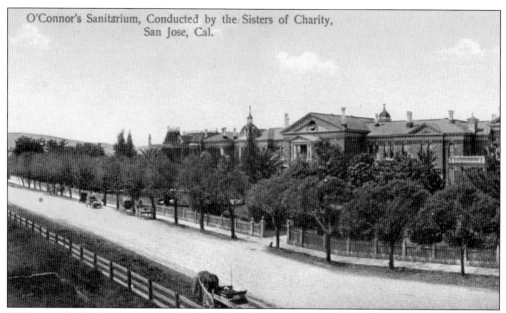

O'Connor's Sanitarium, Conducted by the Sisters of Charity, San Jose, Cal.

O'Connor Sanitarium was erected in 1888 thanks to the generosity of Judge Myles P. O'Connor, a lawyer and businessman who had made a fortune in the California gold mines. It occupied 14 acres of then-rural land on the south side of San Carlos Avenue between Race Street and Meridian Avenue. Designed by local architect Theodore Lenzen, the substantial brick building with two wings was surrounded by lawns and gardens. The sanitarium opened in 1889 under the direction of the Sisters of Charity of St. Vincent de Paul. Originally intended as a home for the aged and poor, by 1900, the sanitarium had evolved into a full-service hospital. In 1955, O'Connor Hospital moved to its present site on Forest Avenue. The old sanitarium was demolished in 1955 and was replaced first by a Sears store and then by a Safeway grocery. (Above, courtesy of the Sourisseau Academy; below, courtesy of the California Room.)

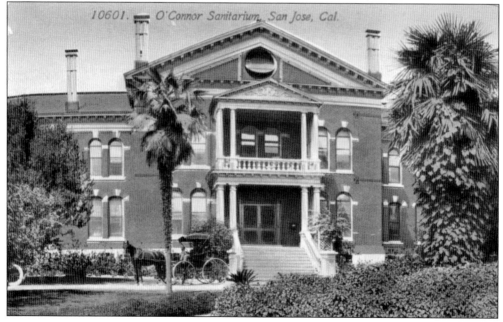

10601. O'Connor Sanitarium, San Jose, Cal.

San Jose, California

This view is looking east on East Santa Clara from the intersection of North Fifth Street. On the left is the First Methodist Episcopal Church, which was destroyed by fire in 1991. Just beyond the church is the 11-story Medico-Dental Building. It opened in April 1928 and was one of four skyscrapers constructed in San Jose before the 1929 stock market crash. (Courtesy of the Sourisseau Academy.)

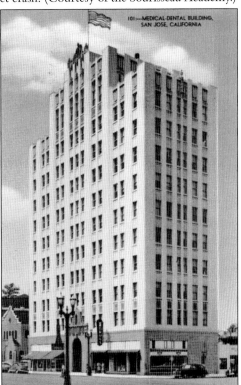

The art deco–style building, with its ziggurat roof, was designed by architect William Weeks. It brought together doctors, dentists, and other medical professionals previously scattered throughout downtown into one easy-to-visit location. In 2005, under the sponsorship of the adjacent Methodist Church, the newly renovated structure was reopened as Vintage Towers, a high-rise apartment building for low-income tenants. (Courtesy of the California Room.)

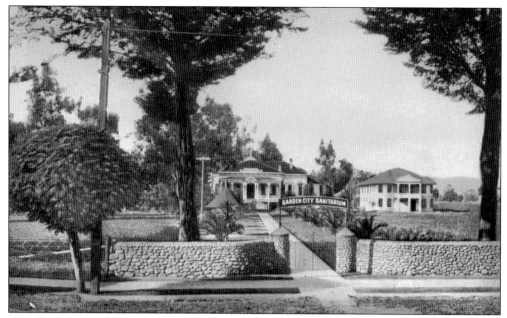

The Garden City Sanitarium was founded in 1897 by Dr. Lewis J. Belknap. The sanitarium occupied a 5.5-acre site on the north side of East Santa Clara Street between Coyote Creek and Twentieth Street. The grounds were attractively landscaped with eucalyptus, redwoods, and palm trees, and other tropical plants. The sanitarium offered a wide range of treatments, including specialized diets, surgery, and massage. The sanitarium had its own dairy herd to supply milk and butter to the patients and staff. The facility could accommodate up to 50 patients. In 1920, Dr. Belknap sold the sanitarium to Columbia Hospital. Five years later, Roosevelt Junior High School was constructed on the site. (Above, courtesy of the California Room; below, courtesy of Sourisseau Academy.)

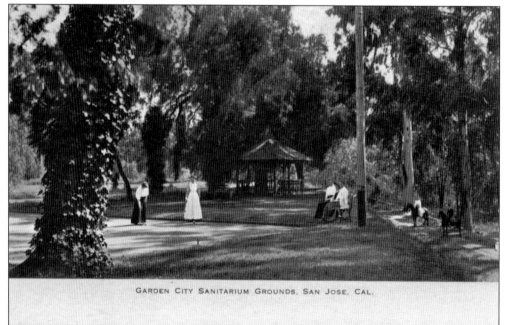

GARDEN CITY SANITARIUM GROUNDS, SAN JOSE, CAL.

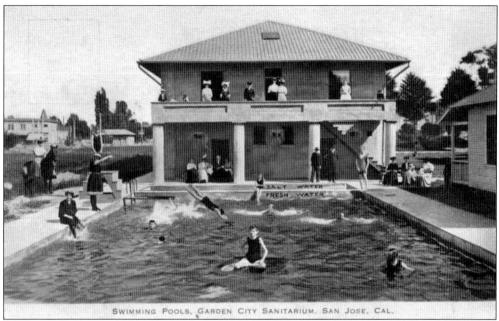

The sanitarium's hydrotherapeutic building was constructed of concrete and measured 40–by–80 feet. (Courtesy of the Sourisseau Academy.)

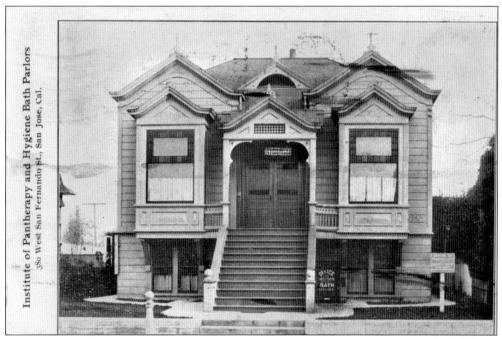

Long before Whole Foods Market, there was the Institute of Pantherapy. The institute was located at 380 West San Fernando Street from 1902 until 1916. It was owned by James and Mary Stevenson. Among other services, it sold a combination grain made from wheat, barley, and rye, as well as other wholesome foods. The site is now covered by the Guadalupe Freeway. (Courtesy of the California Room.)

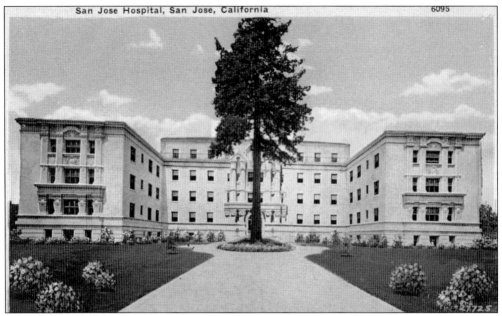

San Jose Hospital was constructed at the urging of a group of local physicians concerned about the lack of hospital beds in the growing community. The reinforced-concrete building opened on June 4, 1923. It was the first modern hospital in San Jose with private rooms, attached bathrooms, and silent bedside alarms to summon nurses. A surgical suite was located in the penthouse, with large windows to admit natural light. (Courtesy of the California Room.)

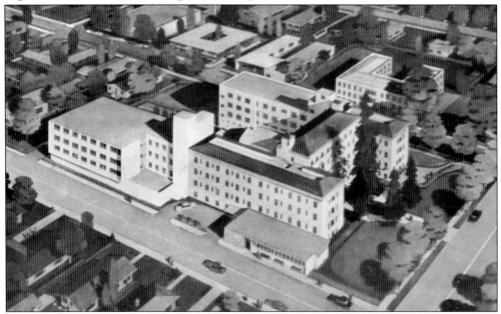

San Jose Hospital was located at the corner of East Santa Clara and Fourteenth Streets. Additions built in the 1950s and 1960s eventually brought the number of hospital beds to more than 600. The hospital changed its name to San Jose Medical Center in 1988. In 1996, the hospital was acquired by Hospital Corporation of America, which decided to close the facility in 2004. (Courtesy of the California Room.)

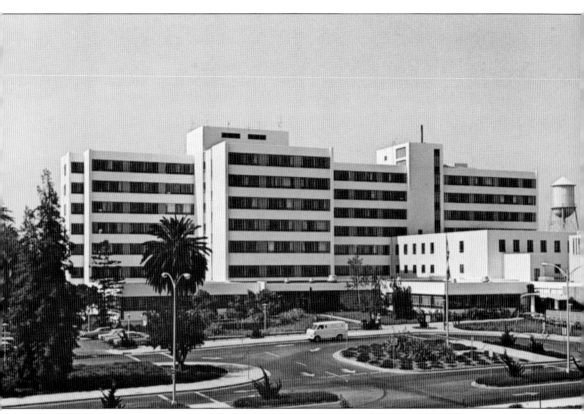

In 1868, Santa Clara County spent $12,000 to buy 114 acres on the west side of Bascom Avenue in order to build a public hospital for those too poor to afford private medical care. In 1875, the county erected the three-story Santa Clara County Hospital at a cost of $14,000. From this nucleus grew the public health care complex now known as Valley Medical Center. Valley Medical Center is a regional trauma center with specialized units treating adult trauma, pediatric trauma, spinal injuries, brain injuries, and burns. In 1999, a new main hospital was opened, replacing the one pictured here, which was seismically unsafe. Valley Medical Center now has a total of 574 beds. The seismic upgrade program continued in 2009, when Valley Medical Center broke ground on a new 168-bed hospital wing due to be completed in 2012. This will enable Valley Medical Center to continue its mission of providing high-quality medical care for residents of Santa Clara County, regardless of their ability to pay. (Courtesy of the California Room.)

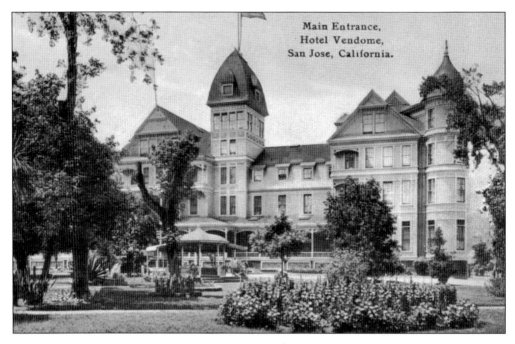

Main Entrance,
Hotel Vendome,
San Jose, California.

For many years, the most luxurious place to stay in San Jose was the Hotel Vendome. The hotel was constructed on the 11-acre estate of Josiah Belden, an early mayor of San Jose. It was designed by Jacob Lenzen in the Queen Anne style. The four-story building was framed in redwood, with a pressed-brick exterior, and was erected at a cost of $250,000. The Hotel Vendome opened on February 7, 1889, and was an instant success. Guests were attracted by the richly furnished rooms and by the beautifully landscaped grounds, where those so inclined could indulge in lawn tennis or croquet. (Both, courtesy of the California Room.)

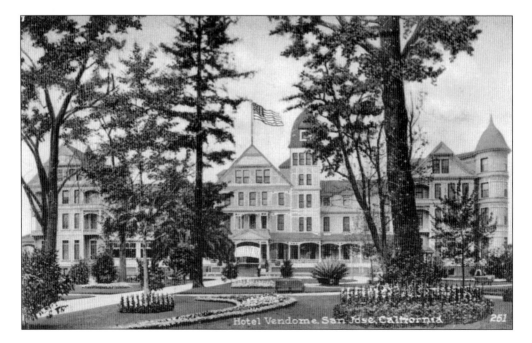

Hotel Vendome, San Jose, California 251

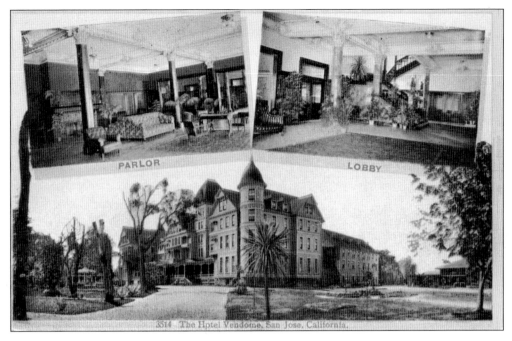

A marbled walkway led from the street to the front entrance, which opened into a rotunda with the main office and lobby. Thickly carpeted corridors led to the parlor, a billiard room, a music room, and a dining room. Elevators took guests to one of 250 rooms, most with an attached bath. Also popular was the sun parlor at the top of the central tower, from which guests could enjoy panoramic views of the valley and the mountains beyond. The hotel went into decline in the 1920s and was demolished in 1930. The grand hotel and grounds were replaced with streets and a housing subdivision. (Both, courtesy of the California Room.)

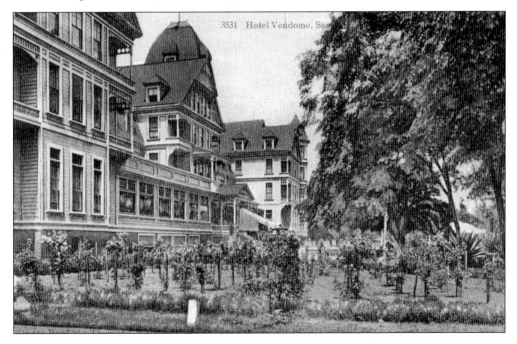

This is a view of the St. James Hotel from St. James Park. It was originally constructed in 1870 by ice and coal dealer Tyler Beach as a two-story business and residence. In 1873, Beach added a third floor and converted the entire building into a hotel. In 1888, he added the fourth floor and enlarged the structure to 225 rooms. Daily rates in the 1890s were $2 to $2.50, including all meals. (Courtesy of the California Room.)

FIRST STREET SHOWING ST. JAMES HOTEL, SAN JOSE, CALIF. 6099

When a friend in Southern California sent Tyler Beach some palm trees, he offered them to the city as a gift. The city refused, saying palm trees would not flourish this far north. Beach planted the trees in St. James Park across the street and arranged for their care. The palm trees survived, but the St. James Hotel did not. It was demolished in 1932 to make way for a new post office. (Courtesy of the California Room.)

HOTEL DORCHESTER, COR. SEVENTH AND SAN FERNANDO STS., SAN JOSE, CAL.

The Hotel Dorchester was a boardinghouse owned by Mrs. Alexander Gilman. It opened in 1910 at 295 East San Fernando Street. In the early 1920s, it was converted into apartments. The building still exists as an apartment house at the corner of North Seventh and East San Fernando Streets, across from San Jose State University. (Courtesy of the California Room.)

5119:—Hotel Montgomery, San Jose, California.

The Hotel Montgomery is another survivor. It was built in 1911 by local developer and civic booster T. S. Montgomery. The four-story reinforced-concrete structure had 142 rooms. After years of decline, in early 2000, the entire hotel was mounted on rubber tires and moved 186 feet to the south to make way for an expansion of the Fairmont Hotel. In 2004, it reopened as a boutique hotel. (Courtesy of the California Room.)

Hotel Sainte Claire,
San Carlos and Market Sts.,
San Jose, California

THE PATIO, HOTEL SAINTE CLAIRE, SAN JOSE, CALIFORNIA

The Hotel Sainte Claire was the result of T. S. Montgomery's ambition to open the finest hotel between Los Angeles and San Francisco. He purchased and demolished the old Eagle Brewery at the corner of Market and San Carlos Streets. He then built an elegant six-story, Spanish Revival–style hotel with 200 guest rooms at a cost of approximately $750,000. Another $125,000 was spent on fine furniture and tableware. It opened in October 1926. A popular gathering spot was the interior courtyard, with its Spanish-style tiled fountain. The Hotel Sainte Claire so dominated this part of downtown San Jose that Will Rogers is said to have remarked, "Looks like the hotel outgrew the town." After a series of owners and renovations in the 1980s and 1990s, the hotel is now part of the Larkspur Hotel Group. (Both, courtesy of the California Room.)

While the Sainte Claire tended to attract an older clientele, a younger crowd could usually be found at the Hotel De Anza. A group of local businessmen built the hotel on part of the old College of Notre Dame property at the corner of West Santa Clara and Notre Dame Streets. Investors spent $500,000 on construction and another $100,000 on furnishings. They decided to name the hotel after early California explorer Juan Bautista de Anza, who passed through the Santa Clara Valley in 1776. It opened in 1931 and quickly became the center of social life for San Jose in the 1930s and 1940s. Among its noted guests were Mickey Rooney, Eleanor Roosevelt, Olivia de Havilland, and Susan Haywood. After closing in 1981, the hotel underwent a $10,000,000 renovation and reopened as a small luxury hotel in 1990. (Above, courtesy of the California Room; below, courtesy of Sourisseau Academy.)

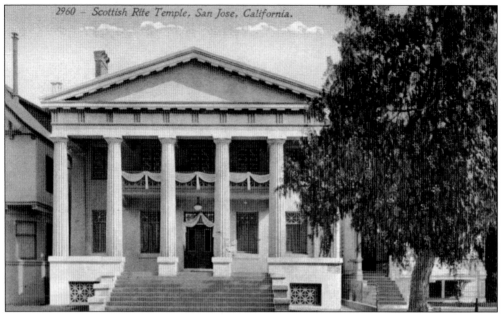

The San Jose Scottish Rite Lodge built this Greco Roman–style temple in 1909 on North Third Street across from St. James Park. Within a dozen years, the lodge had outgrown the building and moved to new quarters. The old structure was demolished in 1983. The modern nine-story St. James Office Building, constructed in its place, incorporated the temple's portico in its front facade, resulting in a strange mixture of architectural styles. (Courtesy of the California Room.)

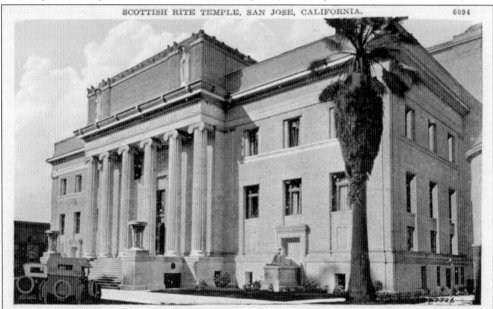

The new Scottish Rite Temple was constructed on the corner of North Third and St. James Streets, just down the street from the old temple. The $400,000 structure was dedicated on March 8, 1925. It held an auditorium that could seat 1,400 and a kitchen that could feed 1,000. After a $6 million renovation, the building reopened in 1981 as the San Jose Athletic Club. (Courtesy of the California Room.)

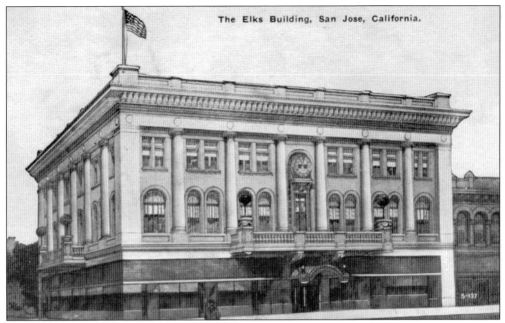

The San Jose Elks Lodge was located at the corner of First and St. John Streets. The August 1921 dedication ceremony was preceded by a grand parade down city streets of 3,000 Elks from all over California. In the early 1960s, the Elks moved to a new building on West Alma Street. The old Elks Lodge was demolished, and a new professional building was erected in its place. (Courtesy of the California Room.)

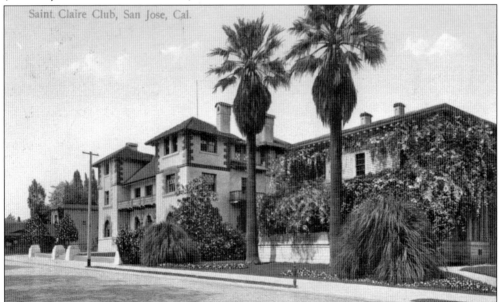

For many years, decisions affecting San Jose were made by civic leaders and businessmen meeting within the walls of the exclusive Sainte Claire Club. The private men's club was founded in 1888 and was moved into this mission-style building in 1896, where members enjoyed a lounge, a library, a dining room, and a social room. The "men-only" club still exists, but its policy of gender exclusion has limited its membership and influence. (Courtesy of the California Room.)

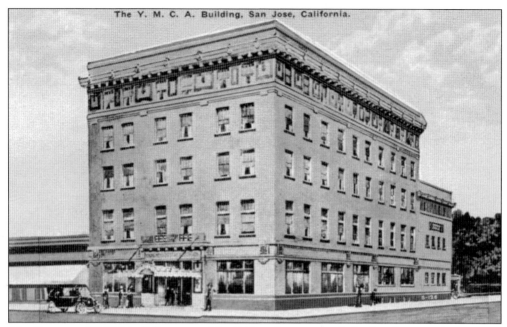

The five-story YMCA building opened in 1913 at the corner of Third and Santa Clara Streets. Ground had been broken the previous year when 300 boys symbolically pulled a long rope with a plow through the site. The $150,000 facility included a reading room, a billiard room, a swimming pool, an assembly room, and 75 dormitory rooms. The facility closed in August 1959, when the YMCA moved to its present location on The Alameda. (Courtesy of the California Room.)

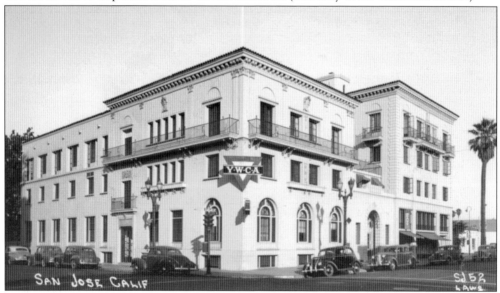

The YWCA building was located at Second and Santa Clara Streets. The original structure on the left was designed by Julia Morgan and was opened in 1916. The four-story annex on the right was added in 1926. The facility included a gymnasium, a parlor, a sewing room, an assembly room, and the first swimming pool in San Jose exclusively for women. The structure was demolished in 1972 and was replaced by the Alquist State Office Building. (Courtesy of the California Room.)

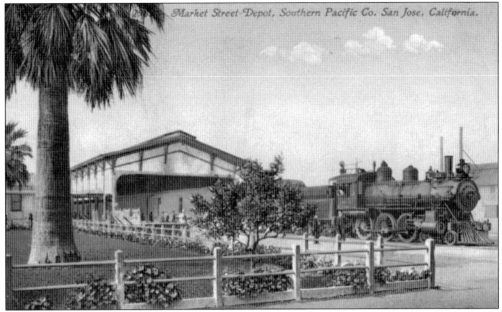

The Southern Pacific Depot in San Jose was located along the north side of Bassett Street between San Pedro and First Streets. In the center of the depot were two separate waiting rooms for men and women. A roof covered the tracks on either side of the waiting rooms to protect boarding passengers from the weather. The depot was torn down in 1936 after construction of a new depot on Cahill Street. (Courtesy of the Sourisseau Academy.)

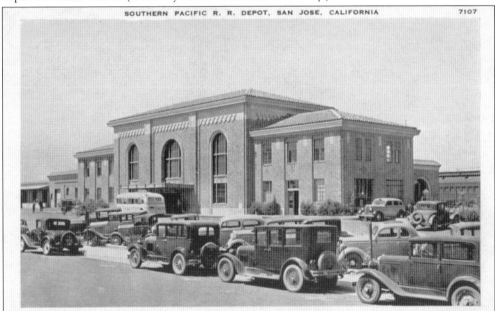

Southern Pacific built the depot on Cahill Street as part of a multimillion-dollar track realignment and upgrade. The depot was constructed in the Italian Renaissance Revival style at a cost of $100,000. The depot underwent a $7.7 million renovation in the early 1990s. In 1994, it was renamed the Rod Diridon Station in honor of local transit advocate Rod Diridon Sr. (Courtesy of the Sourisseau Academy.)

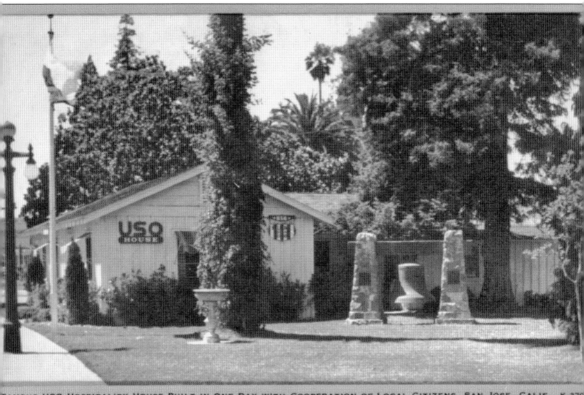

FAMOUS USO HOSPITALITY HOUSE BUILT IN ONE DAY WITH COOPERATION OF LOCAL CITIZENS, SAN JOSE. CALIF. K-370

A shining example of community spirit and cooperation took place in downtown San Jose on the morning of August 16, 1941. At 7:00 a.m. that day, 160 volunteer construction workers joined together to construct a USO hospitality hut at the southern end of Plaza de Cesar Chavez. The building plans were supplied at no cost by architect Charles McKenzie. Local merchants donated $4,500 worth of building materials. Work was halted only for a brief flag-raising ceremony at 8:00 a.m. and for lunch prepared by cooks from Moffett Field Army Air Base in field kitchens set up in the plaza. Thirteen-and-a-half hours later, at 8:24 p.m., the USO hut was finished and ready to welcome visiting military personnel. What was meant to be a temporary structure actually remained as a USO facility on this spot for 35 years. It was abandoned in 1974 and was demolished in August 1976. (Courtesy of the Sourisseau Academy.)

BIBLIOGRAPHY

Arbuckle, Clyde. *Clyde Arbuckle's History of San Jose*. San Jose, CA: Memorabilia of San Jose, 1986.

Beilharz, Edward. *San Jose: California's First City*. Tulsa, OK: Continental Heritage Press, 1980.

Douglas, Jack. *Historical Footnotes of Santa Clara Valley*. San Jose, CA: San Jose Historical Museum Association, 1993.

Gilbert, Benjamin Franklin. *Pioneers For One Hundred Years: San Jose State College 1857–1957*. San Jose, CA: San Jose State College, 1957.

Gilbert, Lauren Miranda, and Bob Johnson. *San Jose's Historic Downtown*. Charleston, SC: Arcadia Publishing, 2004.

Hart, James D. *Companion To California*. Berkeley, CA: University of California Press, 1987.

Historic Resources Evaluation Sheets. San Jose, CA: San Jose Department of Planning, Building, and Code Enforcement, 1977.

Laffey, Glory Anne. *County Leadership: Santa Clara County Government History*. San Jose, CA: County of Santa Clara Historical Heritage Commission, 1995.

Loomis, Pat. *Signposts Revisited*. San Jose, CA: Argonauts Historical Society, 2009.

Nailen, R. L. *Guardians of the Garden City: The History of the San Jose Fire Department*. San Jose, CA: Smith and McKay Printing Company, 1972.

Payne, Stephen N. *Santa Clara County, Harvest of Change*. Northridge, CA: Windsor Publications, 1987.

Peyton, Wes. *San Jose: A Personal View*. San Jose, CA: San Jose Historical Museum Association, 1989.

Santa Clara County and Its Resources: A Souvenir of the San Jose Mercury. San Jose, CA: San Jose Mercury Publishing and Printing Company, 1896.

Sawyer, Eugene. *History of Santa Clara County California with Biographical Sketches*. Los Angeles, CA: Historical Record Company, 1922.

www.arcadiapublishing.com

Discover books about the town where you grew up, the cities where your friends and families live, the town where your parents met, or even that retirement spot you've been dreaming about. Our Web site provides history lovers with exclusive deals, advanced notification about new titles, e-mail alerts of author events, and much more.

Find Your Place in History.